Rembrandt

Christmas 1976

to my dearest wife Irmentraud
with love.

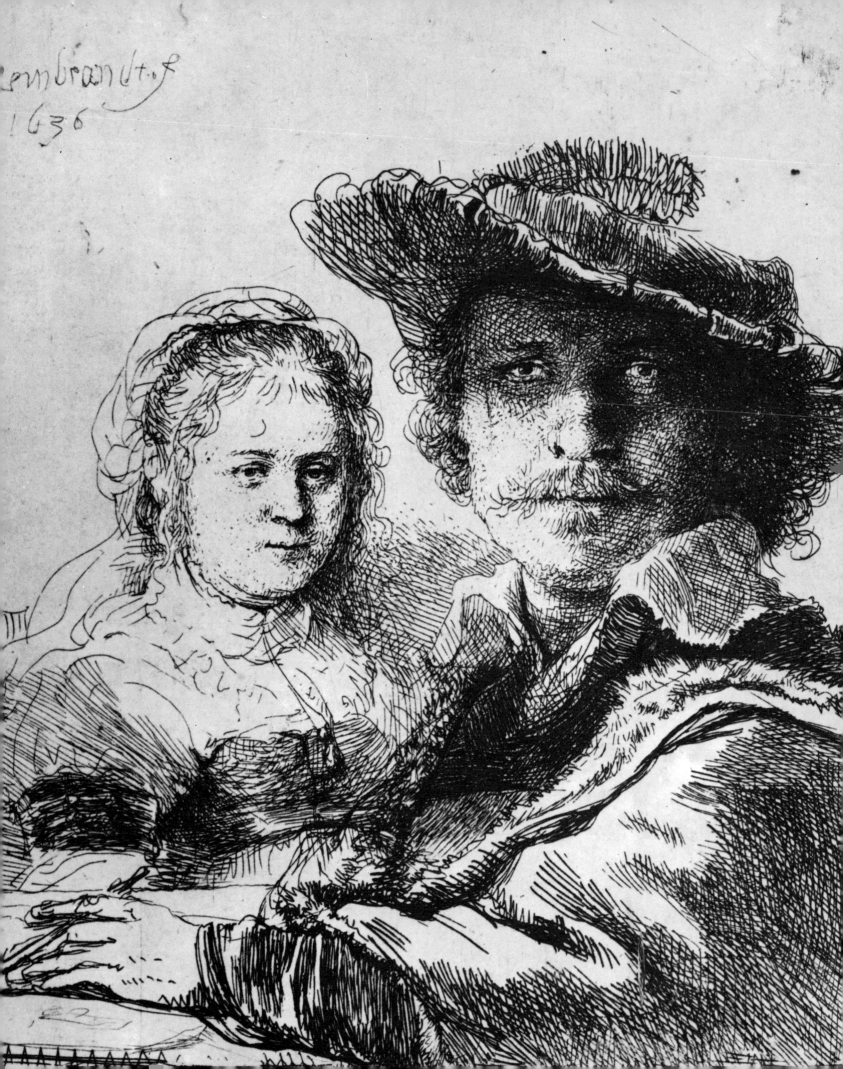

Trewin Copplestone

Rembrandt

HAMLYN
London New York Sydney Toronto

Frontispiece
Rembrandt and Saskia (detail)
1636
Etching
Victoria and Albert Museum, London

Published by
The Hamlyn Publishing Group Limited
London · New York · Sydney · Toronto
Astronaut House, Feltham, Middlesex, England

© Copyright The Hamlyn Publishing Group Limited 1960
First published 1960
Second revised edition 1967
Reprinted 1969
Paperback edition 1970
Fourth edition 1974

ISBN 0 600 37562 5

Printed in Czechoslovakia

Contents

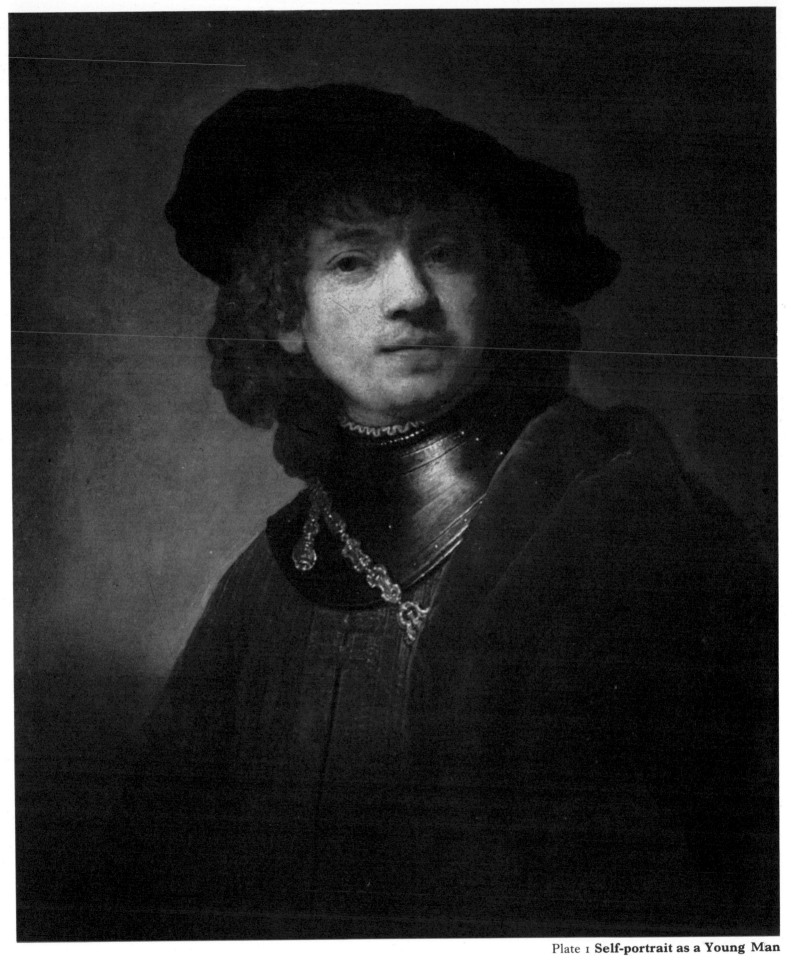

Plate 1 **Self-portrait as a Young Man**

Introduction

Rembrandt is a figure of such importance in European painting that a moderate-sized library might be filled with writings on his life and works: books have even appeared devoted to the consideration of only one painting. The aim of this book, essentially a picturebook, is so to interest the reader in his achievement that he will wish to know more and to visit such examples of Rembrandt's paintings as are within his reach. This short introduction, in examining the course of his life in relation to his achievements, is intended to serve as a background to the illustrations.

If we say that Rembrandt is a typal figure, like, for example, Michelangelo, Titian or Rubens, in the pictorial expression of the consciousness of the European civilisation of which we are a part, we claim for him a distinction which sets him apart from even good painters and surrounds him with an aura of superhumanity. And yet, if painters may have the large importance thus claimed for them, this is where he rightly belongs. It is not too much to say that without his work our culture would be appreciably the less.

There is little in the background of Rembrandt's life to suggest that the times were ripe for his greatness. The Renaissance in Italy had demanded for its fruition the individual variety of Leonardo da Vinci, the incredible force of Michelangelo's Christian Humanism, the calm balanced logic of Raphael's Classicism or the last phase of opulence in Venice. Or again, later, the France of Louis XIV required the delicate purity of Watteau's sophisticated vision. The times seemed to call for these creative spirits. But seventeenth-century Holland had no such apparent impulse. She was, in fact, fighting for her existence and might not be expected to have been concerned at all with the pictorial arts. Moreover, she was deeply Calvinist, and the Protestants have never been notably sensitive to the arts. And again, examining Rembrandt's art, his subjects were not in general those that had in the past produced the greatest creative art. Predominantly, they consisted of solid Dutch merchants peering confidently, singly or in groups, out of an enveloping darkness, some scenes of Dutch contemporary life and a few mythological subjects. The only subject matter having great antecedents was to be found in Rembrandt's religious paintings. Here, however, his art served a different purpose, for the Protestants had not destroyed earlier

Plate 1
Self-portrait as a Young Man
Oil on panel
25 × 21 in (62 × 52 cm)
Galleria degli Uffizi, Florence

This painting was originally wider and higher, a strip of about five inches having been added to the bottom. Rembrandt has left a painted record of his appearance as it changed from youth to old age. There are over sixty self-portraits as well as a number of drawings and etchings. This plate shows a fine example of his early work. Particularly to be noted is his use of hard light on the armour, emphasising the softness of flesh above it. This is also an example of Rembrandt's predilection for clothing his subjects in elaborate costumes.

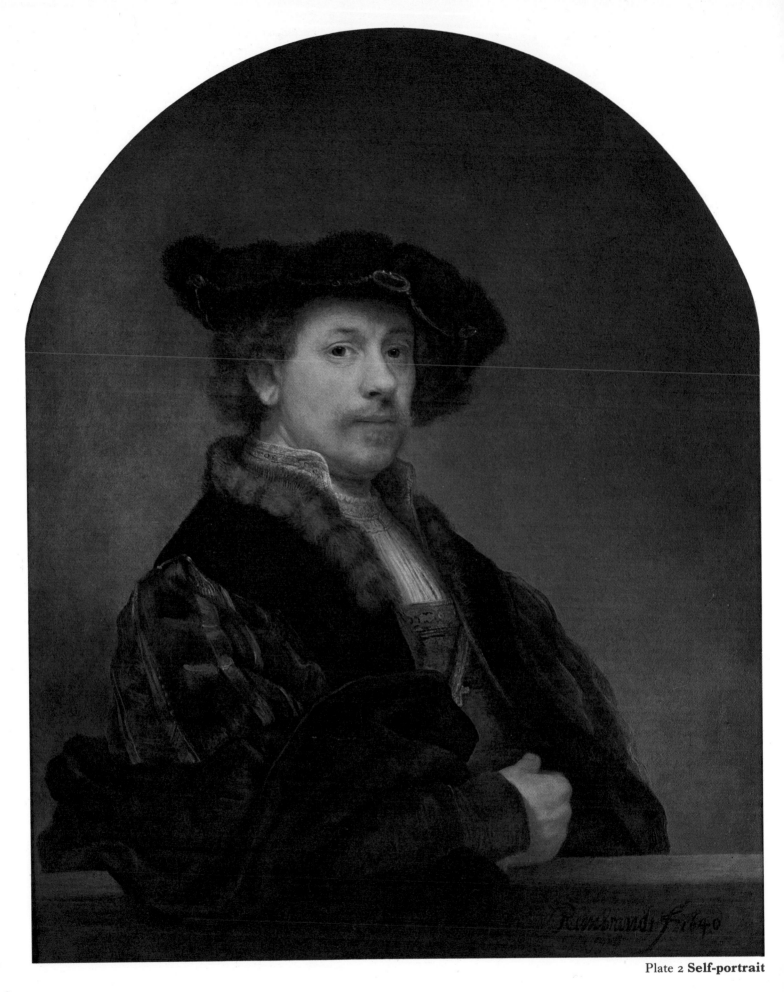

Plate 2 **Self-portrait**

church art to replace it with more of the same kind. Nevertheless it was in and from these conditions that he produced his great art.

In 1609, three years after Rembrandt was born, the States General of the Netherlands, the governing body of the Dutch republic, achieved a surprising and hard-won truce in their war with their nominal overlord, Spain. The Twelve Years Truce which followed secured for Holland an independence from the southern Netherlands, helped to create a sense of nationhood and established her economic health through her great sea trade. It also ensured her religious stability through a deeply held Calvinism. So effective was her trading that for the next half century, with her possessions in the East and West, she was able to become one of the most important states in Europe; so wealthy that she eventually excited the aggressive envy of France and England. Thus, during the first half of the seventeenth century, despite constant intrigue and anxiety concerning her foreign possessions, she was able to improve her condition so greatly that her citizens enjoyed the best standard of living in Europe.

In the trading cities of Holland, including Leyden and Amsterdam — the cities in which Rembrandt lived and worked all his life — the merchants' wealth was not generally reflected in ostentatious living; both their reserved industrious nature and devout Protestantism disdained it. The houses were solidly built, comfortably furnished with heavy furniture and rich brocades and tapestries and with no very large rooms — certainly none to rival the artificial splendour of contemporary France. Contemporary female fashion was sober, employing rich but quietly coloured materials. A good example is shown in *The Bridal Couple* (plate 23). As might be expected, their art was small in scale to suit their interiors. It has been suggested earlier that it might have been supposed that they were little concerned with the pictorial arts, devoting their energies to trade or their country, but this was in fact the period of the greatest pictorial activity in Holland. The explanation lies in the growing wealth of the people, the love for their country and their deep faith in the rightness of their lives. Together these factors created a demand from which a large number of artists were able to earn a living.

Seventeenth-century Holland has probably been more exactly depicted in its activities than any other European society. We can see how all levels of Dutch life were lived, from the scenes of low tavern brawling, drinking and opium smoking, as painted by Adriaen van Ostade or Adriaen Brouwer, to the near elegant *tableaux* of the middle-class society of Terborch, Metsu or Dirck Hals. Pride in the country is shown in the strong landscape school led by Ruisdael, van Goyen, Koninck, Seghers and numerous others. Vermeer, de Hooch, Dou and others created the Dutch *genre* painting, which delighted in careful examination of the calm Dutch interiors, and Rembrandt and Frans Hals were only the greatest of a large number who painted the portraits of the worthy and unworthy Dutch citizens.

Plate 2
Self-portrait
Oil on canvas
39 × 31½ in (99 × 80 cm)
National Gallery, London

Signed: Rembrandt f. 1640 conterfeyct. This self-portrait has been influenced by Raphael's portrait of Baldassare Castiglione, sold by auction in Amsterdam in 1639, at which time Rembrandt made a sketch of it. It shows Rembrandt at the height of his success, and it is interesting to find him relating himself to the great Renaissance humanist, Castiglione, author of *The Courtier*.

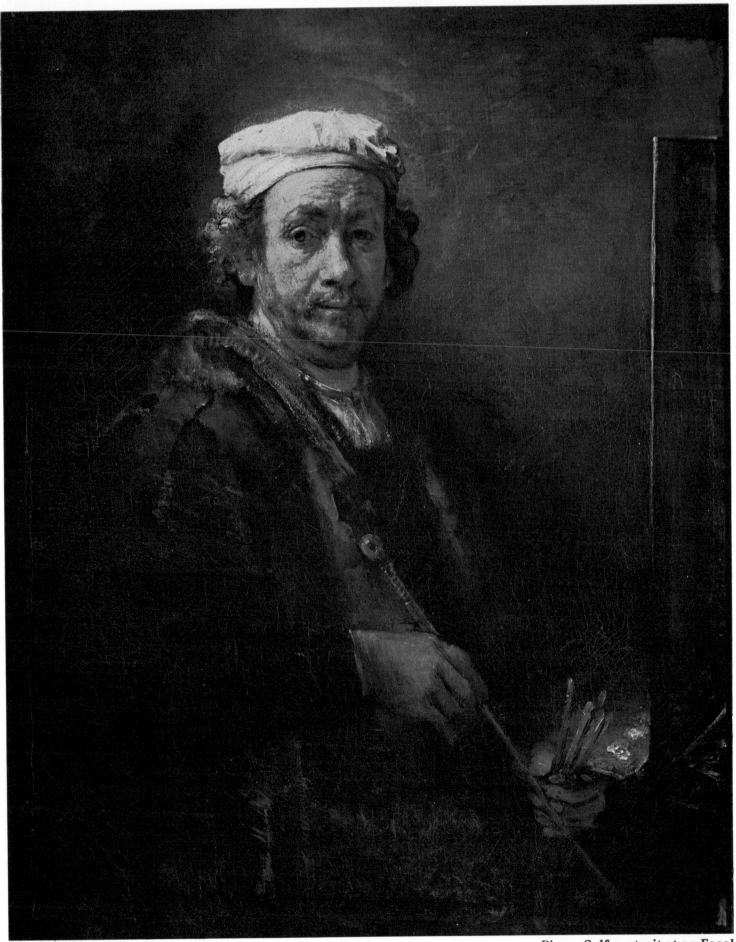

Plate 3 **Self-portrait at an Easel**

Rembrandt Harmensz van Rijn, born on 15th July 1606 at Leyden, the son of a miller, Harmensz Gerritsz, who had taken his name from his mill, called the Rhine Mill for the obvious and sufficient reason that it stood on a branch of the Rhine, was very much a part of this scene. His mother was the daughter of a prosperous baker, and Rembrandt was thus born into the respectable trading middle class. He started his studies in the Latin School at Leyden at the age of fourteen, but early on it seems to have been recognised that he was not destined to make a scholar, his constant preoccupation with drawing eventually persuading his parents into apprenticing him to the painter Jacob van Swannenburgh. He stayed with Swannenburgh for three years, and although little of that pedestrian painter's influence may be discerned in his work he must, while with him, have received the general instruction in drawing which is the powerful foundation of his art. He next entered the studio of Pieter Lastman in Amsterdam. Lastman was a painter of importance in Holland and one of the best known, who had spent some time

Plate 3
Self-portrait at an Easel
Oil on canvas
44 × 34 in (110 × 86 cm)
Musée du Louvre, Paris

Signed: Rem. F. 1660. The signature is a later addition.

The Supper at Emmaus
Caravaggio
c. 1598
Oil on canvas
55 × 77½ in (139 × 195 cm)
National Gallery

This early painting is significant for the obvious 'set-piece' character of its construction. Here Caravaggio is parading his abilities in dramatic expression, drawing and the manipulation of light and shade (*chiaroscuro*). The apparently directly representational treatment of the scene is Caravaggio's innovation which so greatly influenced his contemporaries and successors.

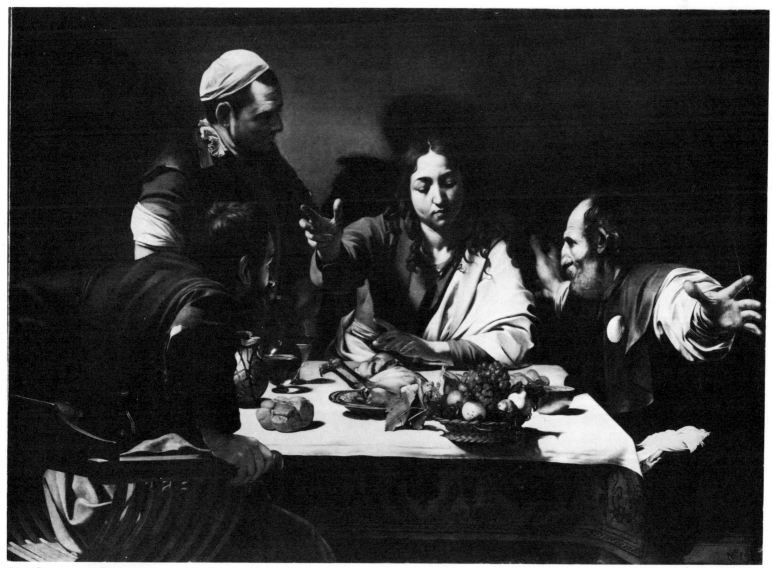

The Supper at Emmaus

Plate 4
Self-portrait
1667
Oil on canvas
$32\frac{1}{2} \times 24\frac{3}{4}$ in (82 × 63 cm)
Kunstmuseum, Cologne

Uncompromising observation is the distinguishing characteristic of Rembrandt's series of self-portraits. Even in a state of near senility, he retained this capacity, as shown in this late work with its air of almost vacuous gaiety. Only a very honest man could have produced so revealing a study of his own old age. The technical virtuosity of the painting is extraordinary and the lively immediacy of the treatment clearly derives from great experience. Compare this with the portrait of himself when young (plate 1) and note the look of almost anxious concentration.

studying in Italy. While there he had come under the influence of Adam Elsheimer, a German painter. Elsheimer was a *chiaroscurist*, a follower of Caravaggio. The influence of the *chiaroscurists* and Caravaggio is so important in the development of the Dutch school and in the understanding of Rembrandt that some space must be devoted to their consideration.

Caravaggio (1573–1610) was one of the great creative painters of the later Renaissance in Italy who worked mainly in Rome. By discerning some of the deficiencies in the prevailing taste he was able to affect those who followed in a profound and revolutionary way. He saw that the Italian genius had deteriorated, that the impetus of Humanism had faded into a dry intellectualism which pervaded both secular mythological and Christian painting. In fact, an inter-identification was taking place, and the figure of the Madonna, for instance, wore the same aspect as the pagan Venus. Paintings were built to the mannered pattern of the painter, and Caravaggio felt the need of a more direct and searching realism in the treatment of his subject whether this was from classical mythology or the Christian story. Thus he chose the ordinary citizens of Rome for his models and gave them the authority and effectiveness of common action. To increase this effectiveness he paid careful attention to the texture of materials, the significance of gesture and, most important for our consideration, the effect of light and shade, which is known as *chiaroscuro*. Using the effect of light in strong contrasts and by dramatic grouping of figures and objects, he revealed a great sense of reality, strength and honesty which enormously influenced numbers of his contemporaries and had a profound effect on the development of seventeenth-century painting. His influence upon painters from northern Europe was particularly notable. Apart from Elsheimer, the Dutchmen Dirck van Baburen, Hendrijke Ter Bruggen and especially Gerard van Honthorst subsequently had considerable influence in their own country when they returned there from Italy. Honthorst was remarkably successful with rather melodramatic *chiaroscuro* interpretations of religious, mythological and *genre* subjects. Through Elsheimer and Lastman the influence of Caravaggio may be traced to Rembrandt. As Rembrandt's teacher, Lastman, in the early years, had a considerable influence upon him, and Elsheimer's Caravaggesque effect on Lastman has already been noted.

Upon leaving Lastman, Rembrandt returned to Leyden and established himself as a painter with some success. His reputation grew and he received many commissions for portraits.

Some of the commissions came from Amsterdam, and at the end of the year 1631 he felt it expedient to move to this prosperous city, which had grown rich on her cloth trade. He lodged first with a dealer in pictures, Hendrijke van Uhlenburgh, at whose house in 1634 he probably first met Saskia to whom he became deeply attached, painting her portrait a number of times (plates 9, 28, 40). His arrival

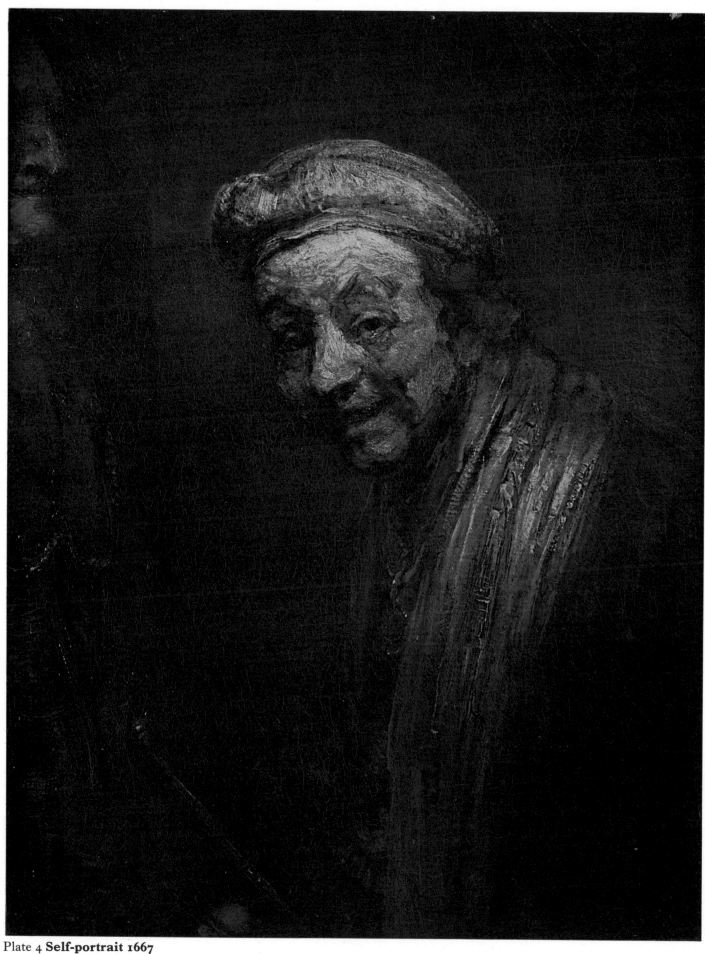

Plate 4 **Self-portrait 1667**

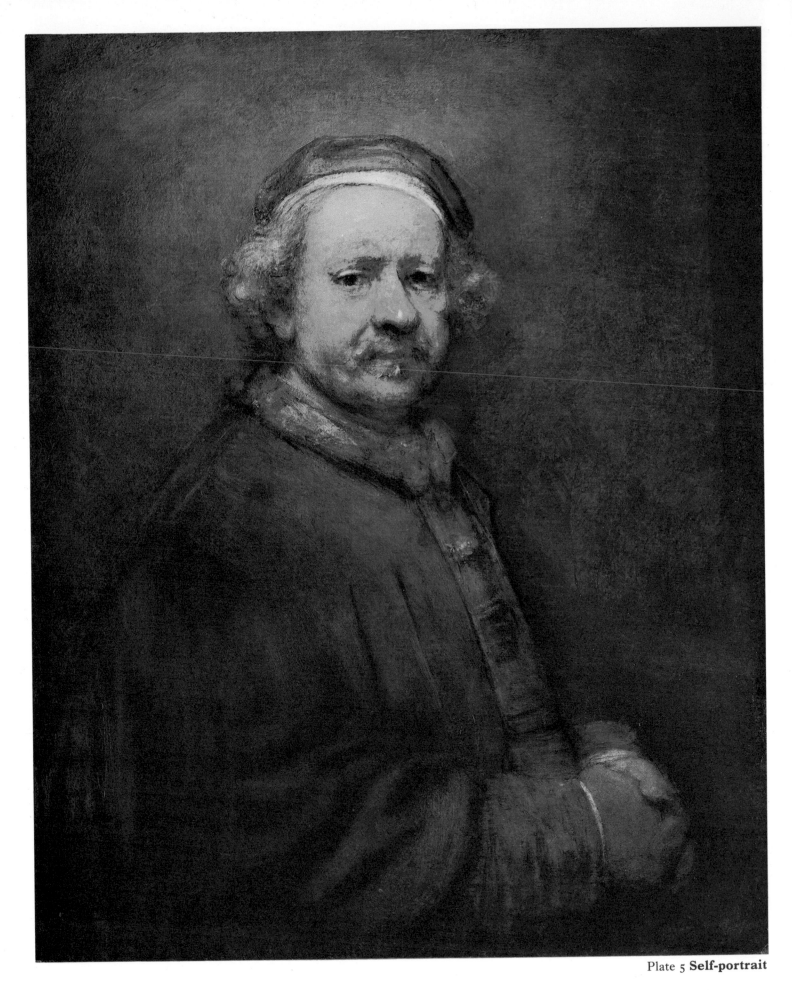

Plate 5 **Self-portrait**

in Amsterdam and his marriage to Saskia were the start of the period of his greatest success, popularity and happiness. In 1632 he received his first important commission. The Amsterdam Surgeons asked him to paint an anatomy lesson with Dr Tulp presiding. Such group compositions were as popular then as now and usually appeared in the same stiff formal ranks of unimpressive but self-important figures. Anatomy lessons as subjects were popular, Dr Tulp was a well-known surgeon, and Rembrandt had an opportunity to which, as a young painter, he responded notably (plate 24). The inclusion of a corpse in the painting, which was quite usual, besides giving evidence of subject, might be expected by contrast to lend a certain liveliness to the other figures, which it often failed signally to do. In Rembrandt's painting the figures have been so well grouped and the dramatic possibilities of the scene so well realised that the painting

Plate 5
Self-portrait
Oil on canvas
33 × 27 in (83 × 69 cm)
National Gallery, London

This portrait was painted in 1669. It shows Rembrandt in the calm of old age and is an example of his later mastery of the oil technique, soft touches of impasto paint delicately building a sympathetic study of uncompromising penetration.

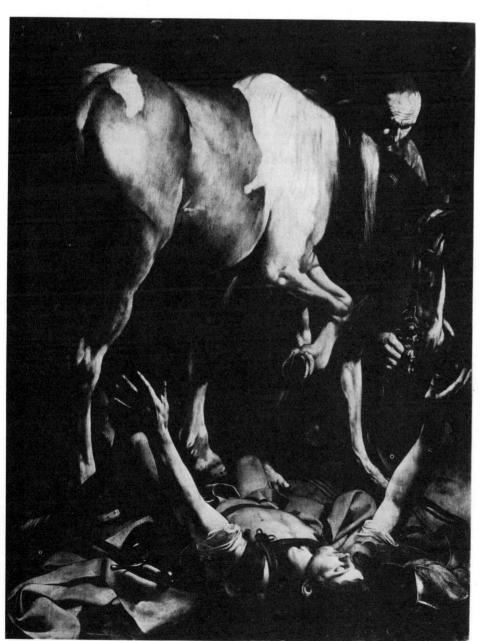

The Conversion of St Paul

The Conversion of St Paul
Caravaggio
1601
Oil on canvas
$7\frac{1}{2} \times 5\frac{3}{4}$ ft (228 × 172 cm)
S. Maria del Popolo, Rome

The importance of Caravaggio in the development of Rembrandt's art can be seen from a comparison of the treatment in this painting with that of the head of an old man in plate 14. In this connection, it should be remembered that Caravaggio's chiaroscuric treatment was his own invention and is not found in the work of his Italian contemporaries. His 'realism'—non-idealised representation of religious subjects—was also welcomed by Protestant painters.

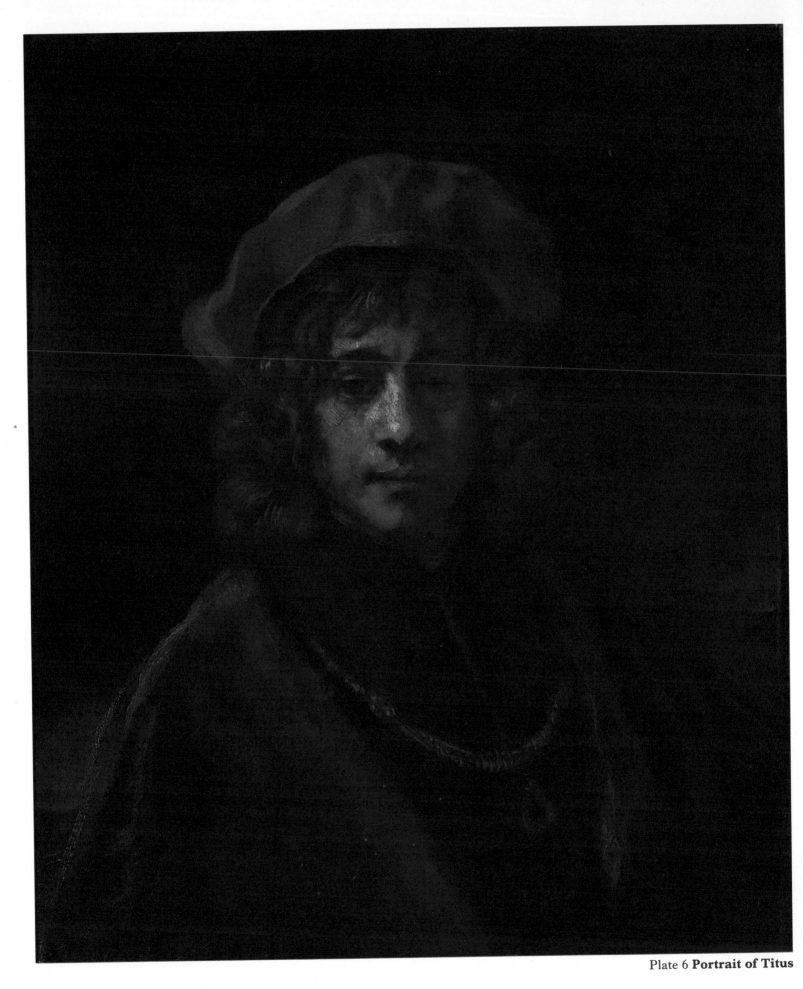

Plate 6 **Portrait of Titus**

The Circumcision

Plate 6
Portrait of Titus
Oil on canvas
$26\frac{1}{2} \times 21\frac{3}{4}$ in (67×55 cm)
Wallace Collection, London

Signed with an initial. Titus was Rembrandt's son and the only child of Saskia to reach maturity. He was one of Rembrandt's favourite subjects, and this portrait, perhaps one of the finest we have of Titus, must have been painted in the late 1650s. Titus's death in 1668 was a great blow to the failing Rembrandt.

The Circumcision
c. 1640–6
Pen and brush drawing in bistre, wash
$9\frac{1}{4} \times 8$ in (23.3×20.3 cm)
Staatliche Graphische Sammlung, Munich

Rembrandt prepared for his paintings with sketches and drawings in which he blocked in the main areas of light and shade, the massing and grouping of figures and indications of pose and gesture. It is in these drawings that the mastery of the dramatic possibilities of a subject can be seen. With great economy and sure line he indicates spatial relationships that reveal his developing ideas. In *The Circumcision* the focus on the child Christ is achieved both with the directional movements of groups of figures and with the tonal pattern of empty areas. It is a simple sketch, but it reveals Rembrandt's mastery of dramatic composition.

hardly resembles the standard type anatomy lesson painting at all. Despite this it is clearly the work of a young man, and some aspects of the painting which are not entirely satisfactory will be considered later.

At this time, too, he was receiving commissions from other important sources, the seal of his success being set when the Staatholder Frederick Henry demanded of him a large Passion series. It was at this time that he began his first landscapes. These, like those of a number of his contemporaries, particularly Hercules Seghers whom he greatly admired, are characterised by a highly dramatic cross lighting and elaborated scenes with waterfalls, bridges, ruins, mills, gigantic trees and small figures. They are only rescued from melodrama by the keen observation of the play and interplay of light on natural objects.

In 1642 Rembrandt completed *The Night Watch* (plate 26). This, probably his best-known painting, was commissioned by the Civic Guard of Amsterdam and was intended to be a picture of the company parading under their captain, Frans Banning Cocq. What had been

expected was a group of a kind familiar throughout Holland, similar to the anatomy group, except on this occasion, of course, the figures struck appropriately militant poses. Cornelis van Haarlem, van der Helst, Frans Hals and others all treated the subject in this way, only Hals succeeding in imparting vitality through his lively virtuosity with the brush. In his painting of the *Civic Guard of the Archers of St George*, Hals produced what is probably the most effective of such subject paintings, not excluding *The Night Watch*, which, whatever its merits, is not a successful example of its type. The guards themselves were dissatisfied and one may sympathise with them, for the individual pretensions of the group which had prompted the commission had not been met. Only a few figures are recognisable, the majority being submerged in the dark areas of the canvas.

The work in fact has been held as signalling a change in Rembrandt's fortunes, and although it is too much to say that it was responsible for the difficulties of his later years it is certain that at about this time the circumstances of his life were greatly changed. About the

Rembrandt's Mother at a Table
1631
Etching
5¾ × 5 in (14 × 12 cm)
British Museum, London

Rembrandt made numerous studies of himself and his family in the form of drawings, etchings and paintings. This etching of his mother was completed just after his father's death when he was only twenty-five. Although perhaps more heavily worked in cross-hatching than he would have used later, it is nevertheless an impressive study of his sitter and evidence of Rembrandt's early interest in etching – an interest he maintained throughout his working life.

Plate 7
Portrait of his Mother
Oil on panel
6¾ × 5¼ in (17 × 13 cm)
Mauritshuis, The Hague.

Painted *c*.1628. Neeltgeen van Zuytbrouk, Rembrandt's mother, was born in Leyden and married Harmensz Gerritsz van Rijn in 1589. He died in April 1630 and she died ten years later. Thus, as might be expected, there are more portraits of his mother than of his father, although several claimed to be of her are falsely attributed.

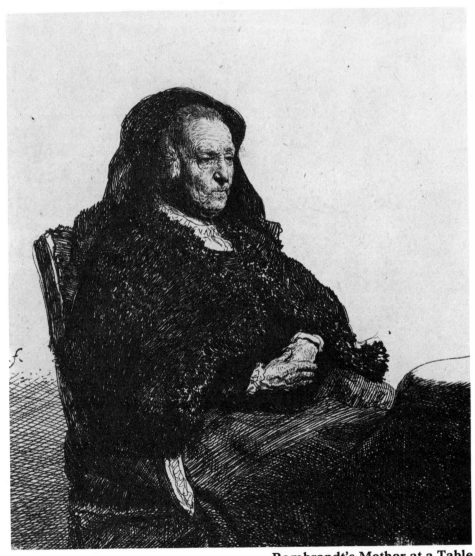

Rembrandt's Mother at a Table

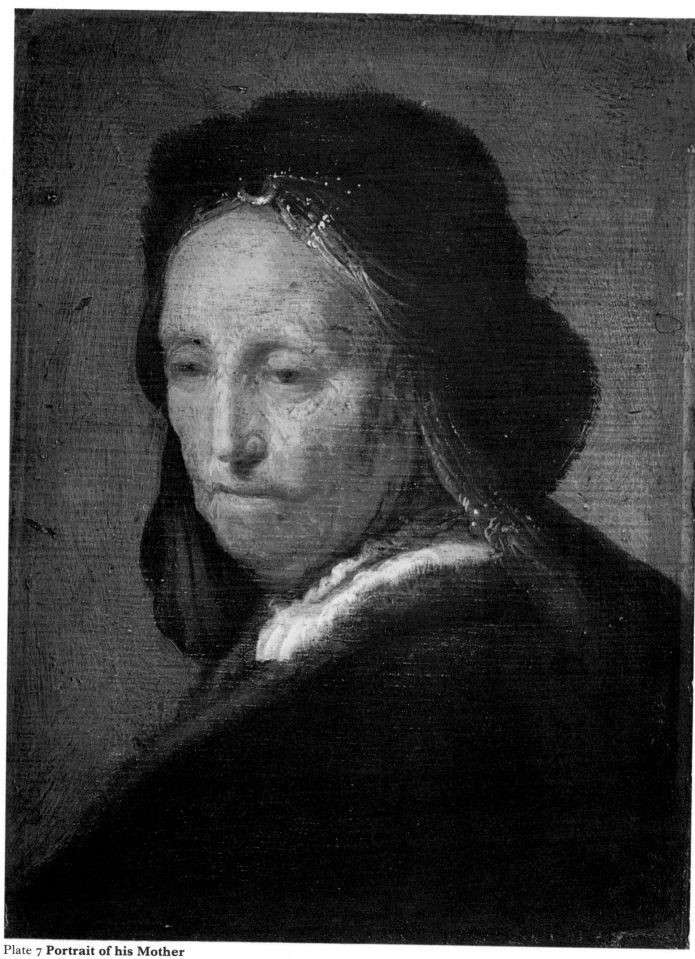

Plate 7 **Portrait of his Mother**

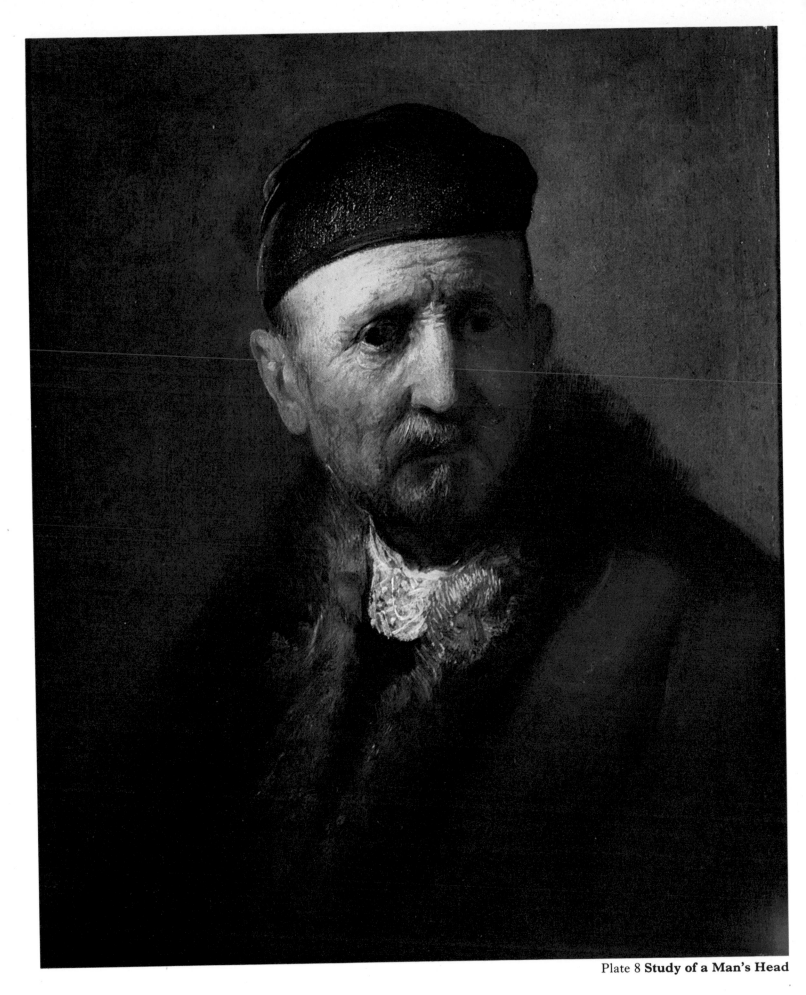

Plate 8 **Study of a Man's Head**

time he had completed the painting, his wife Saskia died, leaving him with their sole surviving child, Titus (plate 6). To look after him, Rembrandt eventually introduced Hendrickje Stoffels into his household, but the loss of Saskia must have been a great blow to him since it is clear he loved her deeply. Before Hendrickje, Geertghe Dirck had been Titus's nurse and, it is claimed, Rembrandt's mistress, but in 1649 she had been removed to an insane asylum. Hendrickje was only twenty-two when she came to Rembrandt and she remained with him for the rest of her life, also becoming his mistress.

As might have been expected in Calvinist Holland, the irregular nature of the household caused something of a scandal—at one time Hendrickje was banished from her church—and this, together with Rembrandt's improvidence in money matters, his overspending on works of art and a falling off in commissions—due in part, no doubt, to the unsatisfactory solution of the Civic Guard subject—led to straitened circumstances, an inability to meet financial obligations and, in 1656, to his declaration of bankruptcy. His own paintings, as well as his collection and the contents of his house, were sold at auction. The times were unsettled; Holland was at war with Portugal and in danger of war with Charles X of Sweden, and, partly as a result of this, the sale realised a sum far below its real value. At this time he was obliged to sign a contract with Titus and Hendrickje to protect his interests, and for most of the rest of his life his affairs were in their hands, he himself receiving little money from his work. (See contract on page 59.)

Titus and Hendrickje had set up as art dealers, and Rembrandt was paid an income as manager—an honorary post, as one may imagine, since any business he managed could not possibly have survived. In any case, he was interested in nothing but his work.

It is characteristic of him, as of other great men, that misfortune and domestic difficulties could not diminish his creative power or his single-minded concentration, and he continued to work, becoming more and more isolated, receiving fewer commissions. In his last years, a figure of respect, he received a new supply of commissioned work on which he laboured until the end.

These last years are the period of his greatest achievement. The portrait of his patron Jan Six was painted in 1654, the same year as the *Homer* (plate 16), this last being done for a noted dealer, Antonio Ruffo. The magnificent painting was one of three done for Ruffo; another, *Man in Armour* (plate 44), is generally held to be of Alexander the Great and the third was of *Aristotle with a Bust of Homer*. He was also called in at this time to decorate the Amsterdam Town Hall (evidence of his maintained reputation), although the work was never fixed in position. It was returned to him for a modification which he never made, and he kept the painting. This is the magnificent *Conspiracy of Julius Civilis*, now in Stockholm. From this time also date *The Bridal Couple* (plate 23), *The Syndics of the Clothworkers*

Plate 8
Study of a Man's Head
Oil on panel
$18\frac{3}{4} \times 15\frac{1}{2}$ in (47×39 cm)
Mauritshuis, The Hague

This is probably a portrait of Rembrandt's father, similar to portraits in the Kassel Museum and the Hermitage, Leningrad, as well as to an etching done in 1630.

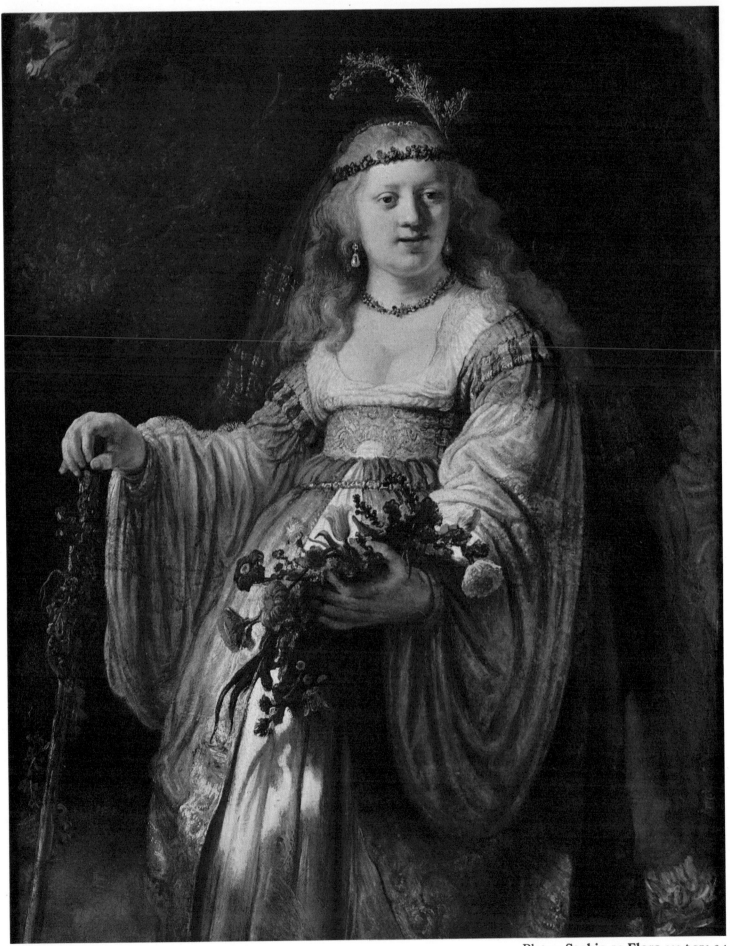

Plate 9 **Saskia as Flora** *see page 24*

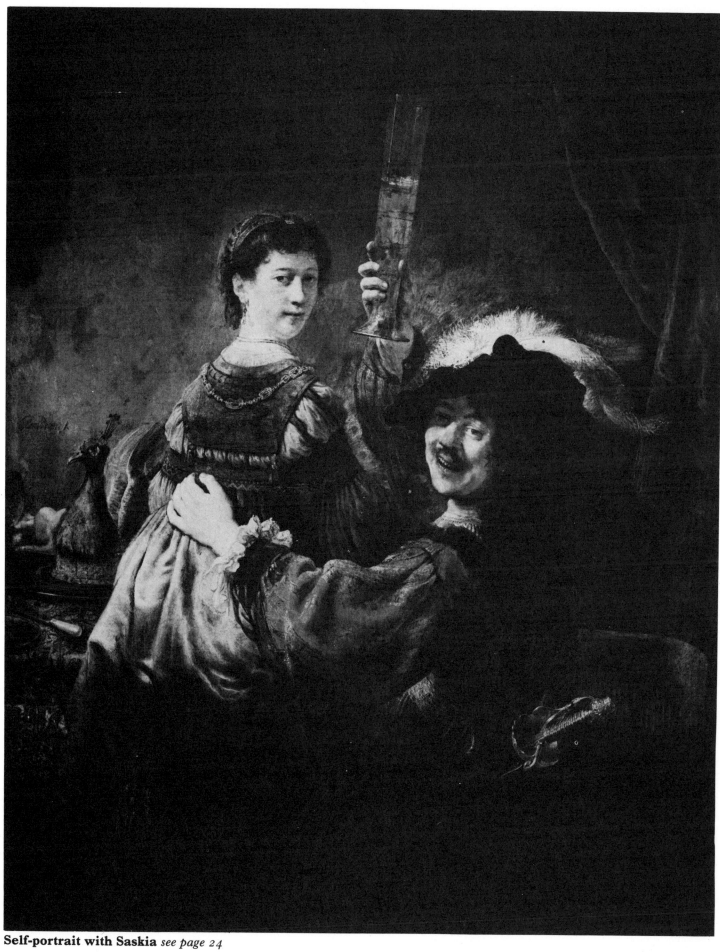

Self-portrait with Saskia *see page 24*

Guild (plate 27), *St Peter Denying Christ* (plate 38) and *The Slaughter House* (plate 48).

When Rembrandt died on 4th October 1669 he was almost alone in the world, Titus and Hendrickje both having died before him. He was survived only by Cornelia, his daughter by Hendrickje. Unfinished in his studio were a *Simeon in the Temple*, now in Stockholm, and a number of etching projects.

This briefly was his life: relatively uneventful, full of the ordinary difficulties of an ordinary life, narrow, circumscribed. There is no evidence that he ever left Holland. He certainly did not feel it necessary to visit Italy, then a Mecca for painters, and his suggested visit to England has not been established. Perhaps it is unfortunate that he never came to England, for one feels that had he painted his great English contemporary, Oliver Cromwell, he would have had a subject worthy of his powers, and such a portrait would surely have been a masterpiece.

Rembrandt lived in a time of change in European society which was reflected in the changing nature of the visual arts. The position of Italy as the intellectual inspiration of Europe had passed, and the Renaissance adherence to classical sources no longer commanded the same acceptance. The rise in the individual powers of the northern European countries, notably of France, seems to have engendered a sophisticated awareness in the arts. We are concerned only to note the effect in seventeenth-century Holland, where, as already observed, national unity and deep Calvinism were the predominating causes. The apparently uncompromising realism of Caravaggio was naturally attractive, and when we remember that it appeared to be in opposition to the prevailing Italian mannered painting which represented, for the Protestant, the art of the Roman Church, we cannot be surprised that it became the principal influence. We have already remarked on its influence in Rembrandt. His pictorial achievement is to use the Caravaggesque method and to add to this his deepening insight into human nature and the pictorial means to express it. This included both a mastery of the significance of human gesture and expression, and the effect of light and colour.

The development of his powers is perhaps best illustrated in the self-portraits. No one painted himself, from eager youth to failing old age, as many times as Rembrandt, and the portraits are the result of urgent analysis rather than personal egoism. They show him laughing, eager, quizzical, confident, disdainful, worried, gay, sad and, in the last painting, in senile decay.

Together with the searching of character there is enquiry into the technical means of expressing it. The paint itself is used as an emotional part of the painting, and ranges in handling from small freely painted panels in which the paint is thickly applied, its ridges rearing into the light and enlivening the surface, to elaborate and carefully painted costume pieces. This aspect is revealed in the late

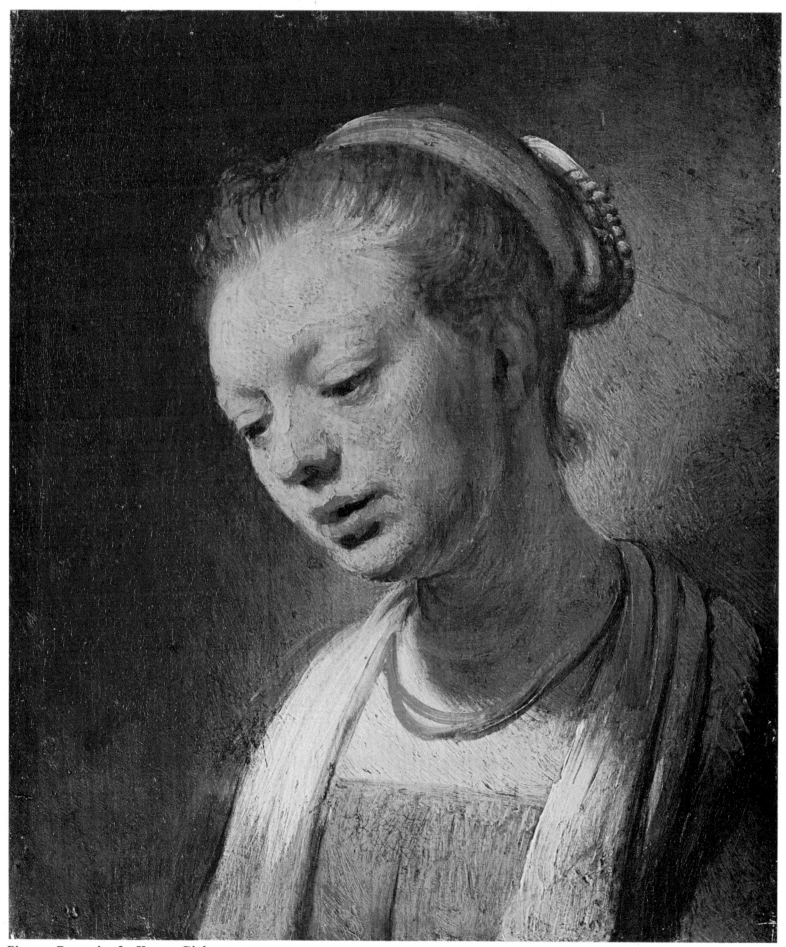

Plate 10 **Portrait of a Young Girl**

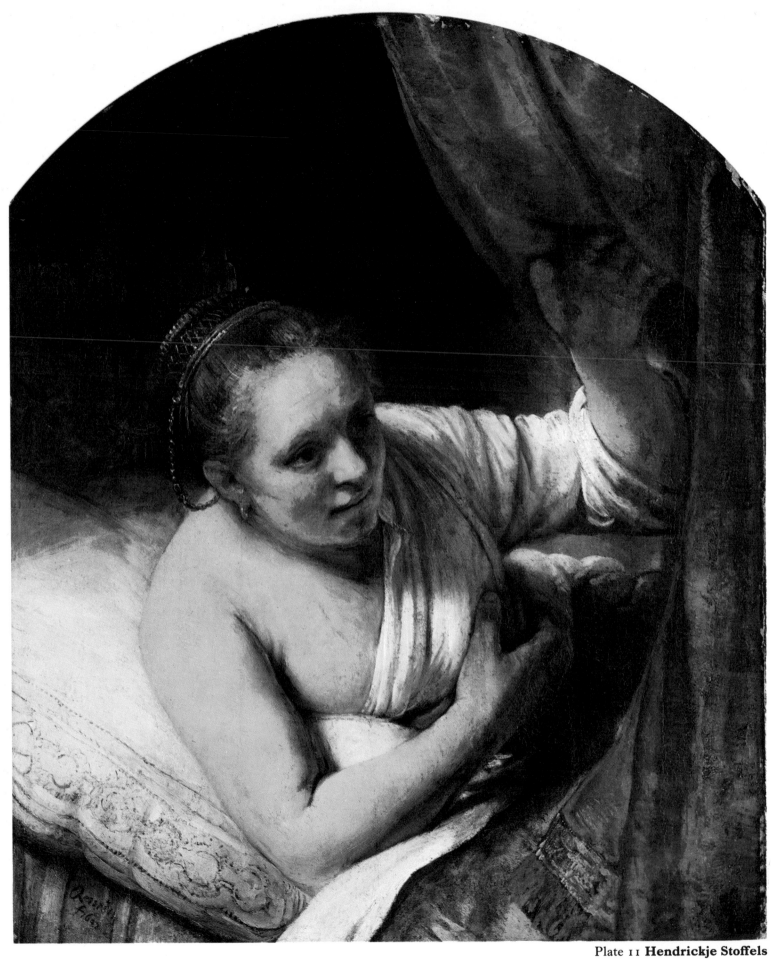

Plate 11 **Hendrickje Stoffels**

portrait, *Self-portrait at an Easel* (plate 3), a deep study, the expression of the soft light searching as it moves over broad forms or as it glances into furrows and throws up the texture of life.

The same searching quality is seen in his female portraits. That his understanding deepened with time is emphasised by a comparison of two studies of old age that are included here: *Portrait of an Old Lady* (plate 18) and *Portrait of Margaretha Trip* (plate 22). The first probably represents Françoise van Wassenhove and, if it does, documents indicate that she must have been over eighty at the time. In his early work Rembrandt came closer to the conventional full lighting of his subject than is usual in his work. The background, from a dark top, lightens at the shoulders, which serves to define their volume and at the same time, characteristically for Rembrandt, gives a sense of impending death – which the expression and downward cast of the eyes seem to bear out. At the same time the drawing in this work lacks the soft, almost gentle, but none the less unerring, penetration which is to be found in the *Portrait of Margaretha Trip*.

Plate 11
Hendrickje Stoffels in Bed
Oil on canvas laid on panel
$32\frac{1}{4} \times 36\frac{1}{2}$ in (81×67 cm)
National Gallery of Scotland, Edinburgh

Signed: Rembr.....f.164... Although it cannot be documented as a painting of Hendrickje Stoffels, this work, together with a number of others of the same model painted around this period, is generally held to be of Hendrickje who entered Rembrandt's household in the late 1640s. The first mention is in 1649. Hendrickje became Rembrandt's second wife, although a provision in Saskia's will may have prevented an official ceremony. The intimacy and freshness, the warmth of light and the richness of the bed hangings make this an unusually appealing portrait of a young girl. There is also a quality of playfulness in the painting which is rare in Rembrandt's work.

Portrait of Titus as a Child
c. 1648
Oil on canvas
$24\frac{1}{2} \times 20\frac{1}{4}$ in (62×51 cm)

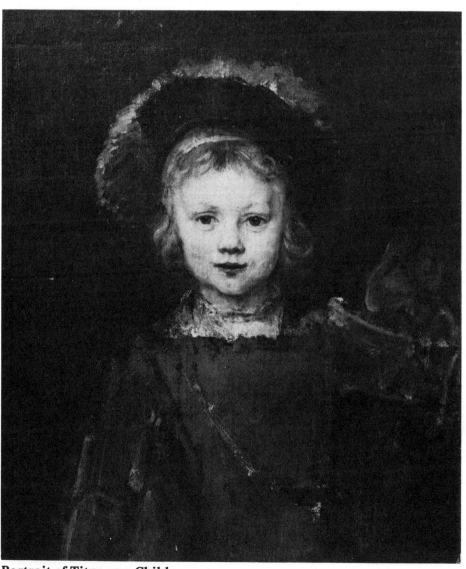

Portrait of Titus as a Child

27

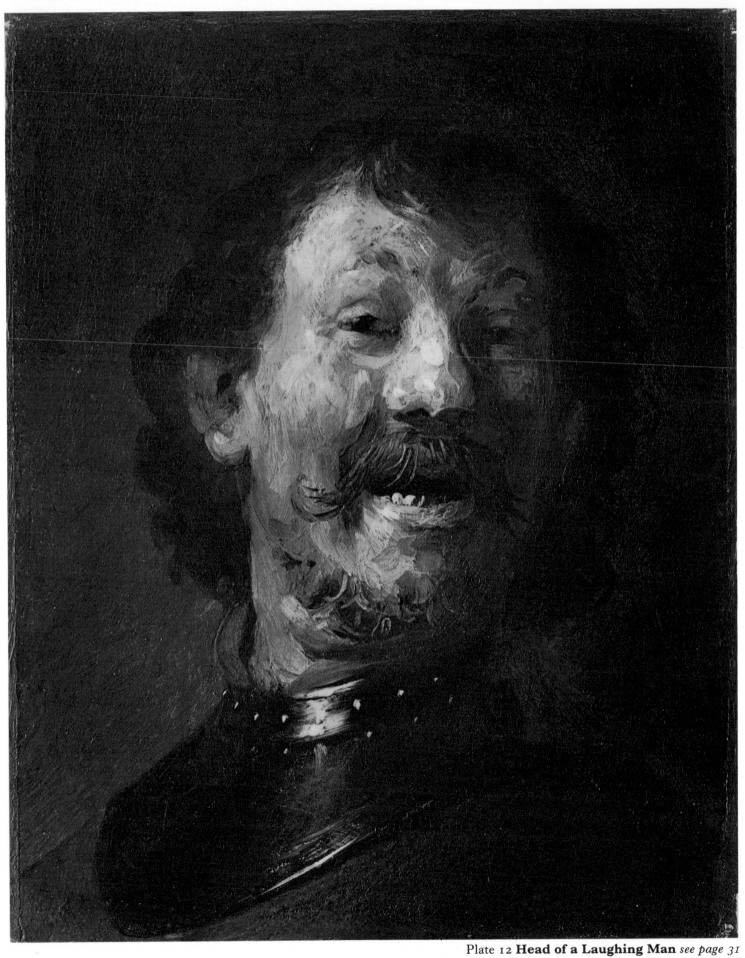

Plate 12 **Head of a Laughing Man** *see page 31*

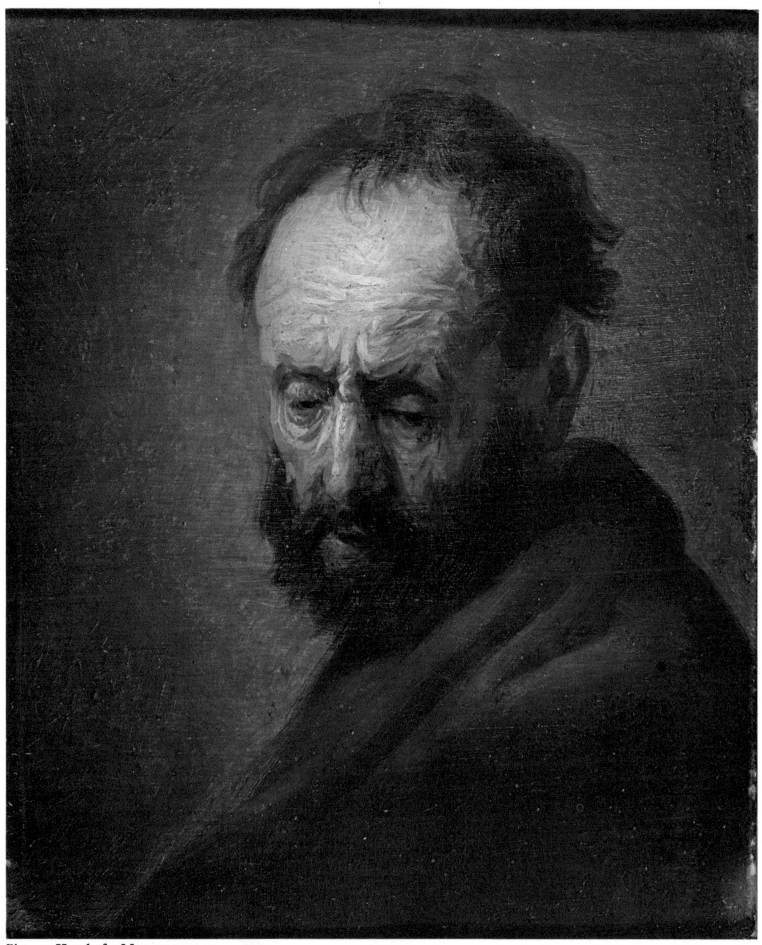

Plate 13 **Head of a Man** *see page 31*

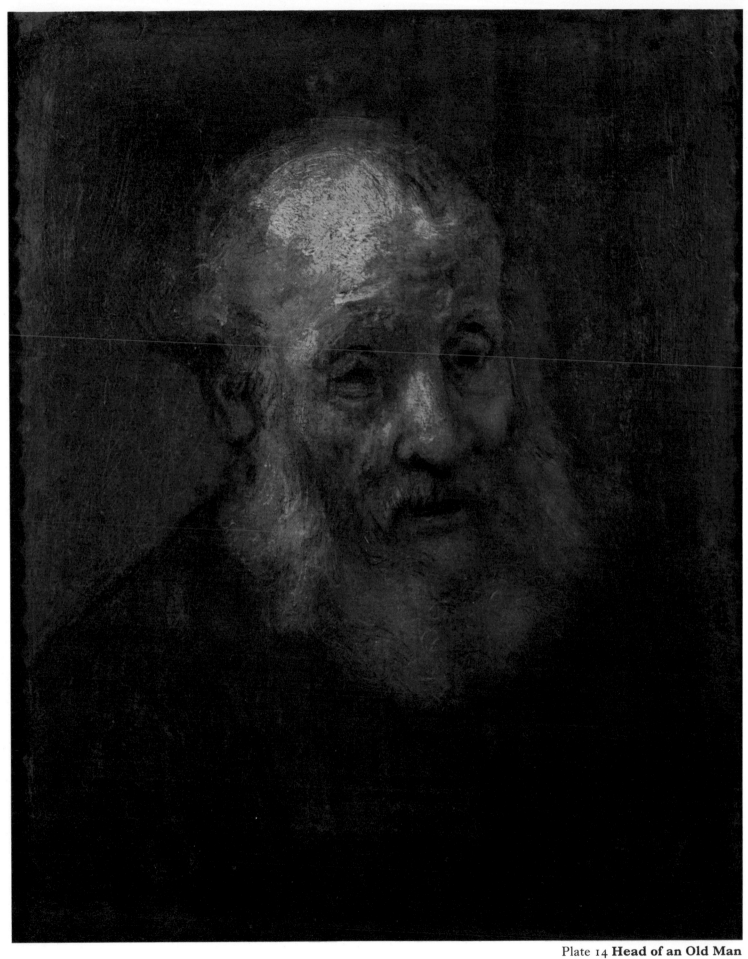

Plate 14 **Head of an Old Man**

But the latter painting was done in 1661 when his understanding and technical mastery were at their highest, and thus we have a deeper, more delicate expression of the resignation of old age: thin parchment skin drawn tight over the bones and pinched senile mouth built up in the most subtle juxtaposed touches of colour.

In the religious paintings the use of contemporary dress and architecture had the effect, in Rembrandt's hands, of heightening the reality of the scene, of giving it a present relevance and importance in keeping with his original researches into the rendering of light – incidentally linking him again with Caravaggio, whose version of *The Supper at Emmaus* in the National Gallery, London, is reproduced on page 11. Rembrandt's treatment of the same subject (plate 37) provides an instructive comparison. Rembrandt felt deeply about religion; for him it was an essential part of life and in many of his works he identifies himself with the subject to the extent of including a portrayal of himself. His moving treatment of the scene in *The Supper at Emmaus* contrasts with the aggressively direct painting by Caravaggio. In Rembrandt's painting Christ is represented in humility in the act of breaking bread which revealed Him to His companions. There is a gentle emphasis of His importance in the arch, a second halo, above his head. The handling of light and colour here is masterly and the single source of light, obscured by the left-hand figure, is not sufficient to account for the radiance surrounding the figure of Christ, which seems to the wondering and apprehensive watchers a further revelation of His divinity. It may also be noticed that Christ is slightly larger in scale than His companions, a form of emphasis which Rembrandt repeats on other occasions and which relates his work to other earlier hieratic treatments. The colour depends on the opposition between warm reds and browns, and the blue-green of the background, in a varying subtle interplay. The delicacy of handling of light in Rembrandt is to be noticed in his late magnificent *St Peter Denying Christ* (plate 38), where the single source of light is thrust close to Peter's face, harshly illuminating its worried lines and picking out on the left only a restless uneasy pattern of highlights on the armour of the brutal soldier. A minor second source, also obscured, reveals a back group of casually interested, uninvolved spectators – emphasising Peter's isolation – as well as the turning, resigned figure of Christ who, although He cannot hear, knows that Peter, with a significant movement of the hand, is disclaiming Him. The overpowering realism of the scene, its sense of actuality, is an example of Rembrandt's involvement in the Protestant notion of human responsibility.

The Stone Bridge (plate 46) represents in this book the small but important section of Rembrandt's *oeuvre*, his work in landscape. His paintings represent only a small section of his study of landscape, and there is a large number of etchings, ink studies and drawings. Most of the paintings were done in the late 1630s, and our illustration

Plate 12
Head of a Laughing Man
Oil on copper
6 × 5 in (15.4 × 12.3 cm)
Mauritshuis, The Hague

Painted in 1628. This small study is enlarged in our reproduction and is evidence of the freedom yet delicacy of Rembrandt's handling, even in his early work. The painting was at one time wrongly thought to be a self-portrait.

Plate 13
Head of a Man
Oil on panel
6½ × 5¼ in (16 × 13 cm)
Ashmolean Museum, Oxford

Recently received from the Turner Bequest, this small sketch is one of a number Rembrandt made for his *Hermit* in the Louvre and is enlarged in this plate.

Plate 14
Head of an Old Man
Oil on panel
10 × 8¾ in (25 × 22 cm)
Musée Bonnat, Bayonne

This is a study for the painting of St Matthew, in the Louvre.

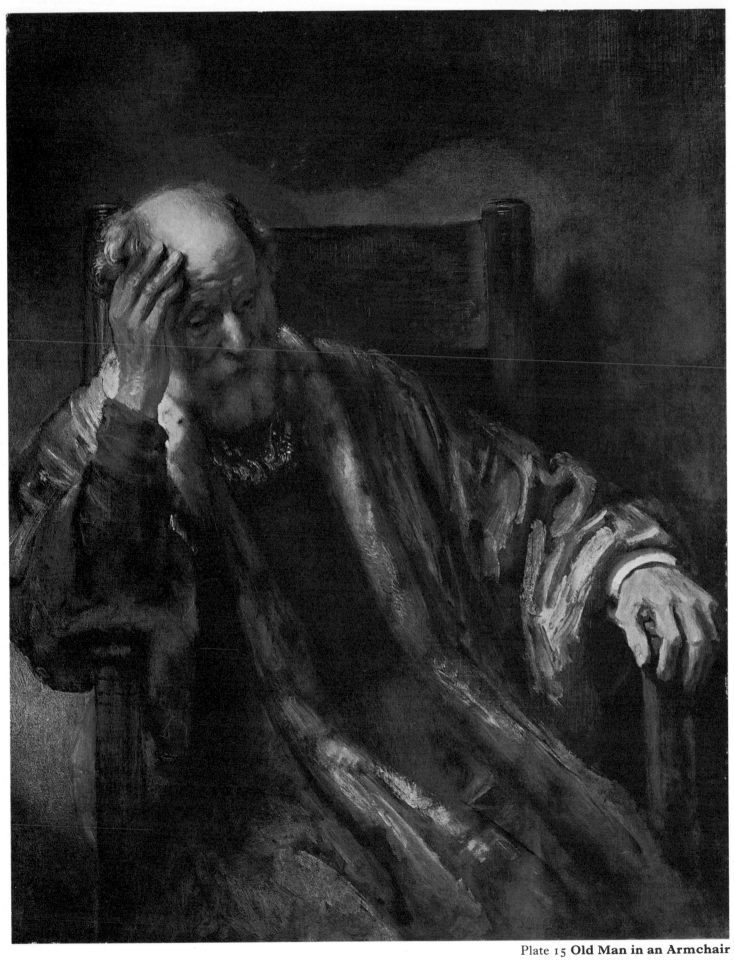

Plate 15 **Old Man in an Armchair**

is a good example of this aspect of his painting. It is particularly illustrative of his dramatic treatment.

Rembrandt's gradual mastery over the years is well illustrated in a comparison of three paintings shown here. *The Anatomy Lecture of Dr Nicholas Tulp* (plate 24), painted in the early years in Amsterdam, is the work of a young man not yet fully capable of mastering a large and difficult composition in all its dramatic possibilities. As previously mentioned, it is an attempt, on a larger plan than is usual with these subjects, to give significance to a number of people obviously assembled for their 'photograph'. That he so nearly succeeds is a great credit to him. Where he fails is in consistency. There is a curious and clear disparity between the eager central group of three who are apparently interested in the doctor's exposition and the other on-lookers who are obviously posing, the two in the left foreground being somewhat out of scale with the corpse. Again, Dr Tulp is himself more stiffly painted than any of the others, with a tentativeness

Plate 15
Old Man in an Armchair
Oil on canvas
43 × 34 in (111 × 88 cm)
National Gallery, London

Signed: Rembrandt f. 1652. The richness of colour and the freedom with which the paint is handled here show Rembrandt at the height of his technical powers. It is a brilliant example of his gift for portraying character by his sensitive rendering of the hands of his sitters. See also the *Old Woman Reading* (plate 19) and *Portrait of Margaretha Trip* (plate 22).

Portrait of Titus as a Young Man
c. 1663
Oil on canvas
Louvre, Paris

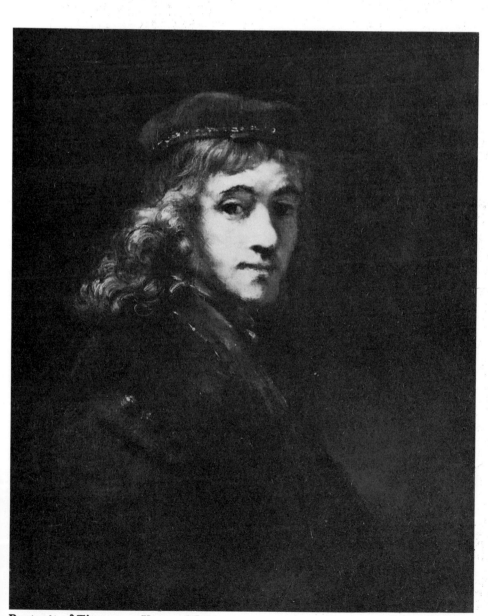

Portrait of Titus as a Young Man

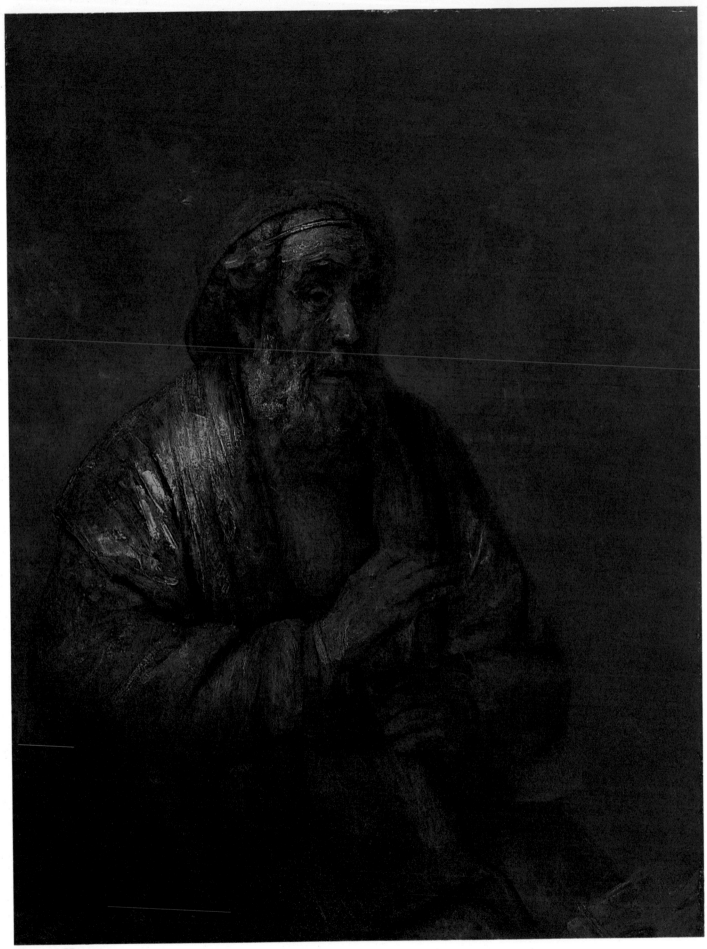

Plate 16 **Homer**

that is rare with Rembrandt. We must, however, remember that this was his first important commission.

The second painting, *The Night Watch* (plate 26), completed in 1642 at the height of Rembrandt's success, has been commented upon, but the increased command of *chiaroscuro* and the organisation of space in the picture should be emphasised. For Rembrandt, it is clear, the problem was less one of painting likeness than the control, over a large area, of light falling on surfaces and glowing in open spaces. Light bathes the air and surrounds the hard volumes of the figures, softening and rounding the forms. Nevertheless, this is not the complete expression of his capabilities, for there is an unresolved problem of the dramatic significance of the grouping of the figures which was earlier shown in *The Anatomy Lecture of Dr Nicholas Tulp*. There is in *The Night Watch* a certain variance between the dramatic light pattern and grouping, and gestures of the figures, which creates a dichotomy where none should exist.

Lastly, his most complete masterpiece and one of the great works of Western art, *The Syndics of the Clothworkers Guild* (plate 27), shows how, out of a subject not likely to be held inspiring, without heroics and in a flattish light, Rembrandt can build a painting of unequalled grandeur, revealing much insight into human nature and subtlety of observation. The Syndics are portrayed as interviewing one of their members, and all are clearly imbued with a sense of responsibility to him; each is a separate portrait of compelling power while remaining a part of the whole pattern. The composition, held together by the rich warmth of the table cover, is apparently simple, but such is the care taken with the disposition of light and dark in relation to the proper significance of the figures that the unalterable rightness of scene is borne in on the viewer. Like the member they are interviewing, the observer searches each face for evidence of character, trying to discern a latent sympathy or antipathy. It is as if humanity is ranged before us. This painting is in fact a unique expression of the two strands of his achievement, the dramatic interpretation of the human spirit and the technical mastery of the revelation of light.

In this short study examining the paintings of Rembrandt, little mention has been made of his etchings. Rembrandt is the great master of this art and it would be inappropriate to consider them merely as an appendix to his main work.

Etching was an abiding passion throughout his working life and he expressed perhaps as much in this form as he did in painting. Drawing too was, for him, an essential tool, constantly used to explore the possibilities of composition in preparation for painting and etching. His whole work therefore—drawing, etching, painting—should properly be considered as a whole as the single expression of one of the most powerfully endowed spirits in the whole gamut of Western art.

Plate 16
Homer
Oil on canvas
44 × 33 in (108 × 82 cm)
Mauritshuis, The Hague

The painting has been cut down on the right and left and the surviving signature is 'andt f. 1663'. Although this painting is obviously based on a replica of an antique bust, it is one of Rembrandt's fine translations into his own pictorial terms through which he gives a deeper insight into his subject. The blindness and intellectual power of Homer are both expressed, simply and effectively. Homer is depicted dictating his verses to a scribe whose fingers may be discerned at the lower right corner.

Biographical outline

Plate 17
Portrait of Gérard de Lairesse
Oil on canvas
45 × 34 in (112 × 87 cm)
Lehman Collection, New York

Signed: Rembrandt f. 1665. Gerard de Lairesse was a Belgian painter living in Amsterdam who had notable success with 'classical' paintings. He was extremely ugly, having a depressed bridge to the nose and the upper lip which usually accompanies it. This could partially have accounted for his determination to succeed not only in the arts but with women. His debauchery was well known and it is believed that he contracted syphilis. This is noticeable in the portrait which, despite obscurity of origin, is now generally held to be of Lairesse. Lairesse's attitude was unsympathetic to Rembrandt, and in 1669, the year of Rembrandt's death, he described him as 'a master capable of nothing but vulgar and prosaic subjects ... who merely achieved the effect of rottenness'.

1606
15th July. Rembrandt Harmensz van Rijn born in Leyden. His father was a miller and his mother the daughter of a baker.

1620
He entered Leyden University as a student in the Latin School. Did not stay more than a year or so, but during this time appears to have acquired the interest in mythology which he made the subject of many of his paintings.

1620-4
Between these years he became, first, a pupil of the painter van Swannenburgh in Leyden (Swannenburgh was mainly a landscape painter much influenced by Italian art) and subsequently studied under Pieter Lastman in Amsterdam, later becoming his assistant. (Lastman was a pupil of Adam Elsheimer—a German who was influenced by the Italian *chiaroscurists*.) The influence of late Italian Renaissance art and particularly that of Caravaggio was being transmitted to northern Europe at this time, and it is likely that Rembrandt absorbed this influence, as part of his training, through both his masters.

1625
Became an independent painter and returned to Leyden where he worked until 1631.

1628
Engaged Gerard Dou as a pupil and assistant. (Dou subsequently became extremely successful with meticulously painted *genre* subjects. He also painted in the Rembrandt manner.)

1630
His father died.

1632
Having established himself in Amsterdam in 1631, he received his first important large group commission, *The Anatomy Lecture of Dr Nicholas Tulp* (plate 24).

1634
Married Saskia van Uhlenburgh.

Plate 17 **Portrait of Gérard de Lairesse**

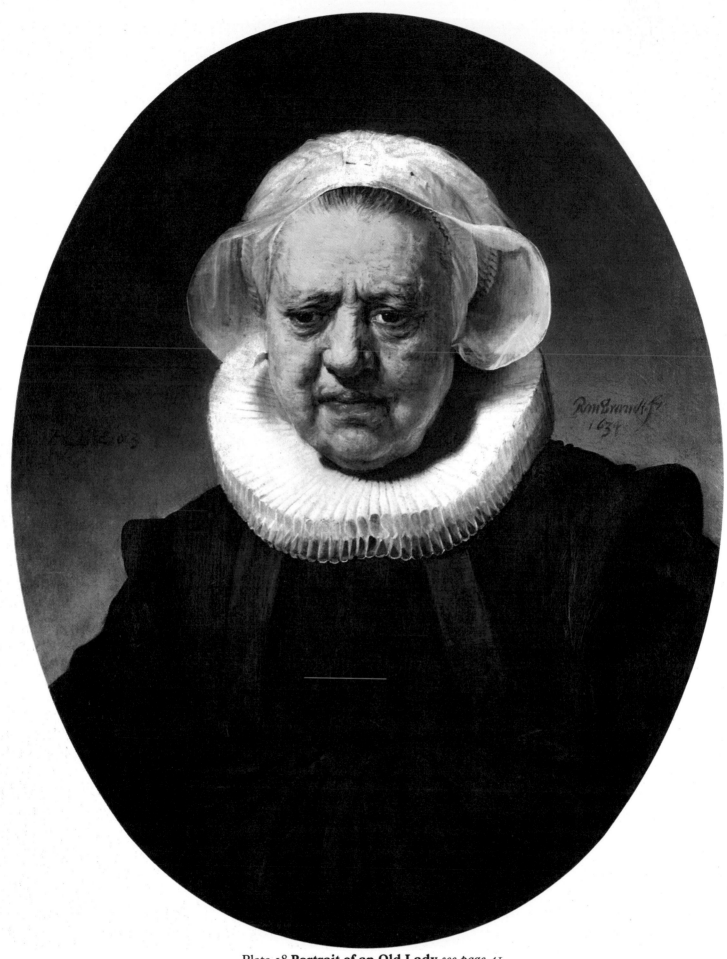

Plate 18 **Portrait of an Old Lady** *see page 41*

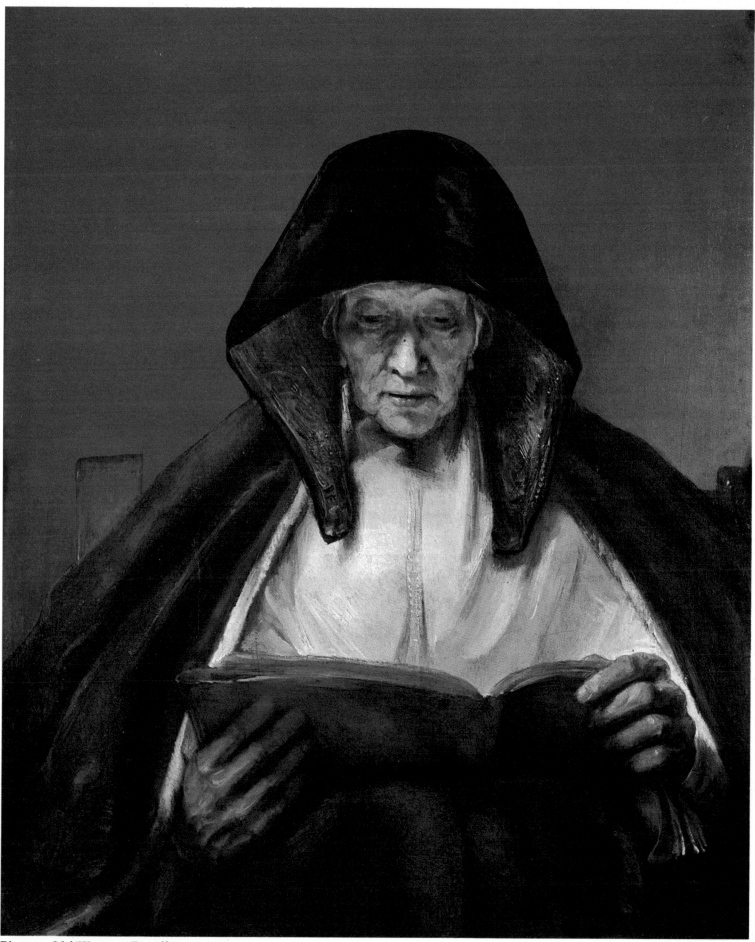

Plate 19 **Old Woman Reading** *see page 41*

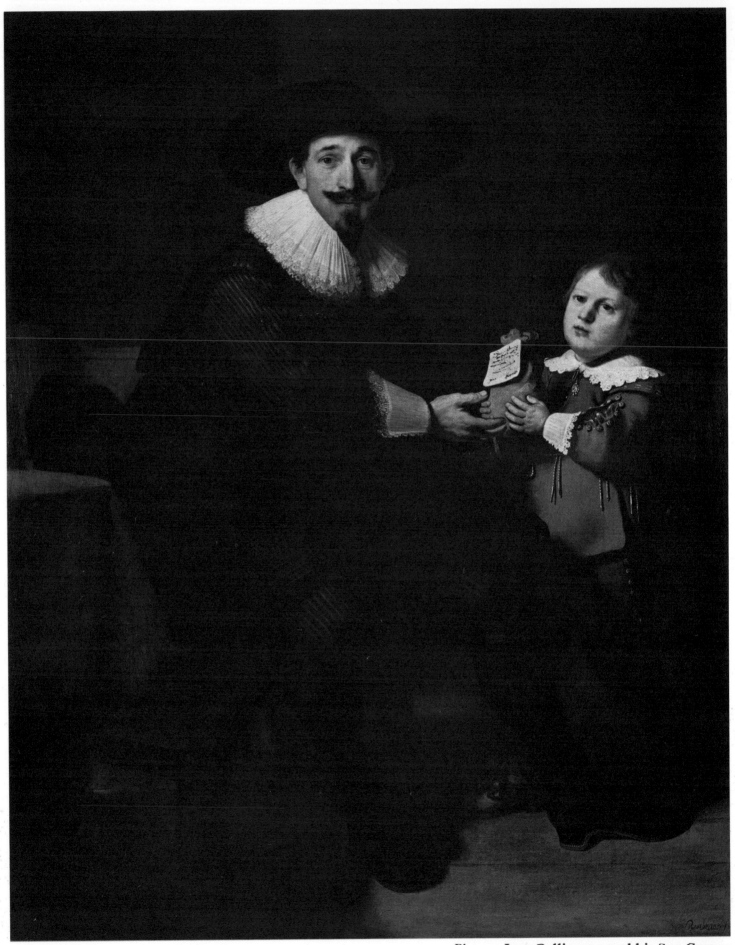

Plate 20 **Jean Pellicorne and his Son Gaspar**

1636
First large landscapes painted.

1640
His mother died.

1641
Titus born.

1642
Saskia died.

Painted the large group known as *The Night Watch* (plate 26) for which he received the large sum of 1,600 guilders. In the same year Carel Fabritius became his pupil. (Fabritius, probably Rembrandt's most accomplished follower, was killed in his early thirties in a powder explosion in Delft.)

c. 1645
Hendrickje Stoffels became his housekeeper and nurse to his son Titus.

1645–55
During this period he received fewer commissions and accumulated many debts. Nevertheless he continued to work, producing paintings, drawings and etchings.

1656
He was declared bankrupt and an inventory of his goods was made.

1658
His possessions, including his house, were sold at auction and he never subsequently managed his own affairs. In order to escape his creditors he was obliged to enter into a financial agreement with Titus and Hendrickje which made him their employee. (See page 59 for a translation of the interesting contract arranged between them.) However, during the next ten years he produced his finest and most important work and this also despite the loss of both Hendrickje, who died in 1664, and Titus, who died in 1668.

1662
Painted *The Syndics of the Clothworkers Guild* (plate 27).

1669
4th October. He died, leaving Cornelia, Hendrickje's child.

Plate 18
Portrait of an Old Lady
(possibly Françoise van Wassenhove)
Oil on panel (oval)
27 × 21 in (68 × 53 cm)
National Gallery, London

Signed: Rembrandt f. 1634. This painting is to be compared with the portrait of Margaretha Trip (plate 22). It is an early expression of age and does not show the same depth of understanding or technical mastery as does the latter. At the time, if the subject of the portrait is, as suggested, Françoise van Wassenhove, she was aged 83.

Plate 19
Old Woman Reading
Oil on canvas
31¼ × 26 in (80 × 66 cm)
His Grace the Duke of Buccleuch and Queensberry, Selkirk.

Signed: Re ... Painted about 1654, this portrait of an old woman shows Rembrandt's abiding sympathy for and understanding of old age, its isolation, peace, resignation, and concentration. The subject has never been identified, but there is another brilliant portrait of this old woman seated in an armchair which is in the Hermitage in Leningrad.

Plate 20
Jean Pellicorne and his Son Gaspar
Oil on canvas
61 × 48¼ in (155 × 123 cm)
Wallace Collection, London

Signed: Rembrandt fct. Companion piece to *Susannah Pellicorne and her Daughter Eva* (plate 21). Painted *c.*1635–7. Pellicorne was a member of the rich merchant class upon which the prosperity of the Netherlands depended. He married Susannah van Collen in 1626; their daughter was born in 1627 and their son in 1628. Pellicorne had inherited his business from his father and Gaspar carried it on. This is a good example of the large number painted by Rembrandt and others of the merchants and their families. It shows the Dutch as industrious and confident without affectation or display. It should perhaps be noted that the painting and its companion piece were done when the Dutch were fighting, in the Thirty Years War, for their independence.

Historical background

Plate 21
Susannah Pellicorne and her Daughter Eva
Oil on canvas
61 × 48½ in (155 × 123 cm)
Wallace Collection, London

See caption to plate 20.

Rembrandt's contemporaries

The first half of the seventeenth century in Europe was one of considerable artistic activity. Rembrandt had a number of important contemporaries in the other countries of Europe as well as in his own. To enable the reader to relate him to these other artists some of the more important have been listed below.

ITALY

Italy was then divided, as it had been for centuries, and the influence of France and Spain was paramount. The most important painters were:
Caravaggio (1573–1610)
The Caracci
Domenichino (1581–1641)
Guido Reni (1575–1642)
Guercino (1591–1666)

Perhaps the most typical and certainly one of the most productive artists of the period, the age of Baroque, was the sculptor Gianlorenzo Bernini (1598–1680). Like a number of his contemporaries he was also an architect and painter. Francesco Borromini (1599–1667) was an important Baroque architect and Pietro da Cortona (1596–1669) was both architect and painter.

SPAIN

This is the period that was covered by the reigns of Philip III and Philip IV. It is the great period in Spanish painting and includes all the most important painters, with the exception of Goya. They were:
El Greco (c. 1541–1614)
Francisco Ribalta (c. 1565–1628)
Joseph de Ribera (1591–1652)
Francisco de Zurbarán (1598–1664)
Diego Velásquez (1599–1660)
Esteban Murillo (1618–82)

FRANCE

During the early part of this period, after the assassination of Henry IV, the Regency of Marie de Médicis was followed by the reign of Louis XIII. He was succeeded in 1643 by Louis XIV, and Versailles

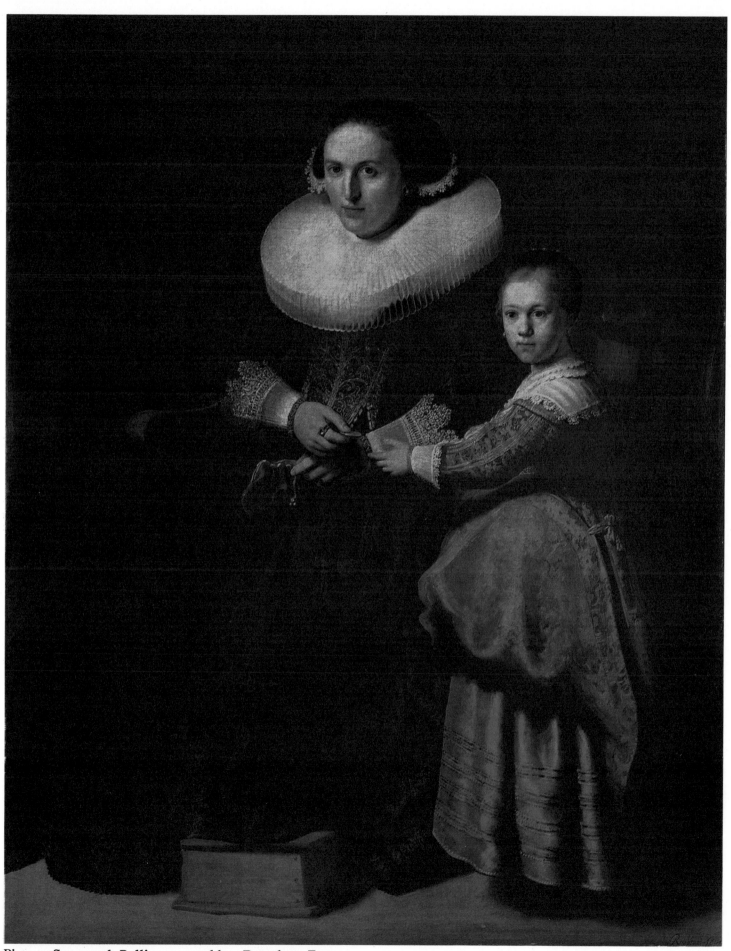

Plate 21 **Susannah Pellicorne and her Daughter Eva**

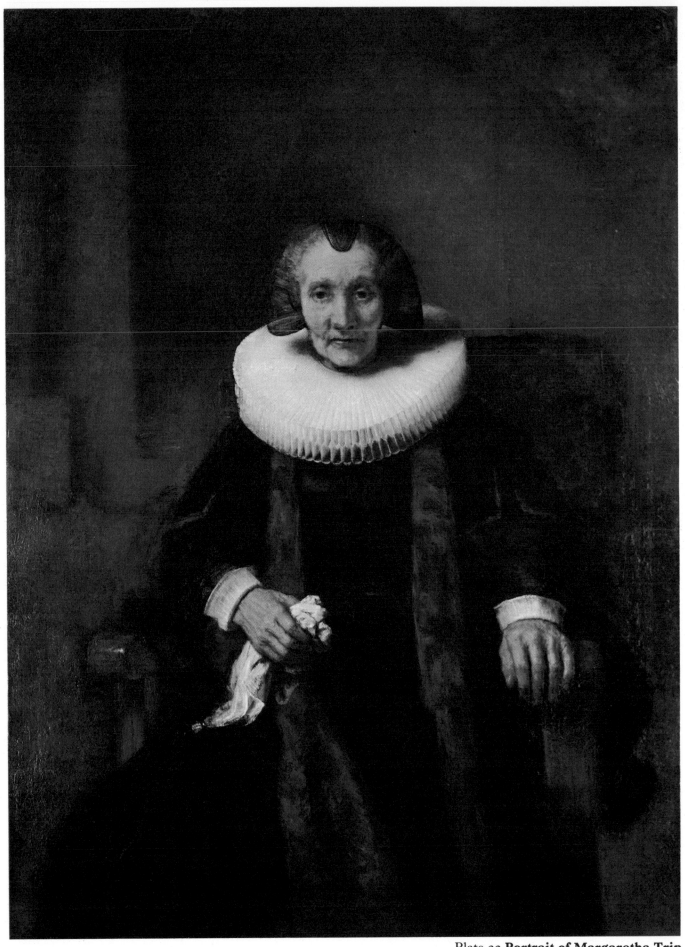

Plate 22 **Portrait of Margaretha Trip**

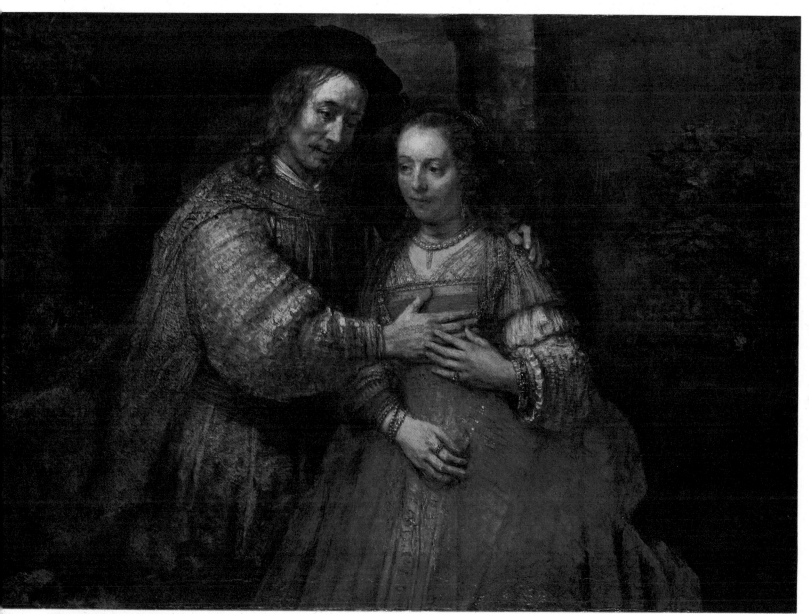

Plate 23 **The Bridal Couple**

Plate 22
Portrait of Margaretha Trip
Oil on canvas
50¾ × 38 in (128 × 96 cm)
National Gallery, London

Signed: Rembrandt f. 1661. Margaretha Trip née de Geer (1585–1672) married Jacob Jacobsz Trip (1575–1661), a merchant of Dordrecht whose portrait is also in the National Gallery, London. The couple was also painted by Nicholas Maes and J. G. Cuyp. This painting is a most beautiful example of Rembrandt's mastery of the expression of the delicate texture and thin transparency of skin in old age. Notice particularly the hands.

Plate 23
The Bridal Couple
Oil on canvas
48 × 65½ in (120 × 165 cm)
Rijksmuseum, Amsterdam

Faint traces of signature, Rembrandt, at bottom right corner. This painting is sometimes known as *Ruth and Boaz* or *The Jewish Bride*. It was painted *c.* 1658 and is a most sensitive, sympathetic study, comparable with the Brunswick *Family Group*. It has been suggested that it may be a portrait of Titus and his wife done on their marriage.

45

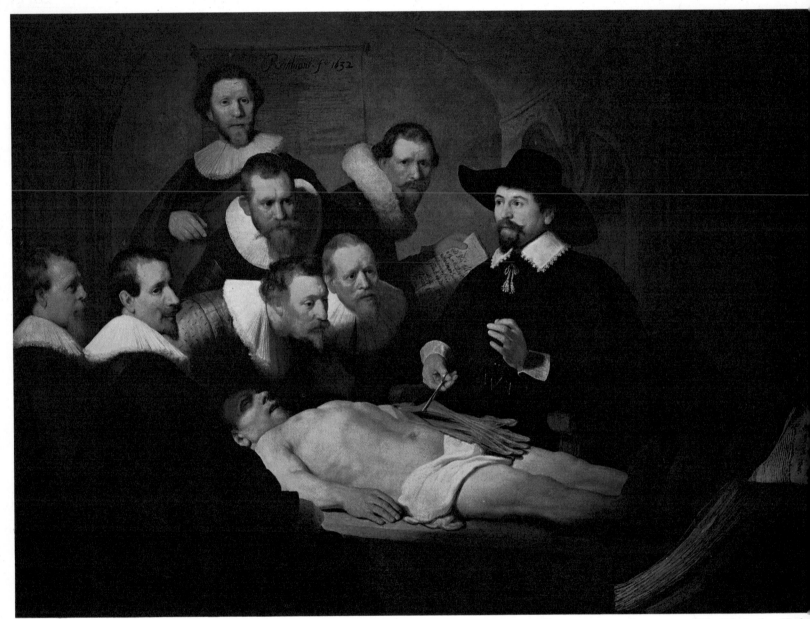

Plate 24 **The Anatomy Lecture of Dr Nicholas Tulp**

Plate 24

The Anatomy Lecture of Dr Nicholas Tulp
Oil on canvas
65 × 86½ in (162.5 × 216.5 cm)
Mauritshuis, The Hague

Signed (repainted signature) and dated 1632. This was Rembrandt's first important group commission and represents Dr Tulp (1593–1674), one of the most famous physicians and surgeons of his time, demonstrating the muscles of the forearm with the help of 'Vesalius' propped at the feet of the corpse. In 1628 Tulp was nominated Praelector in Anatomy at Amsterdam, became a Burgomaster and was elected representative of the States of Holland and East Friesia. Mathjis Kalkoen, who is nearest to the Professor, is holding a piece of paper which lists the names of the other spectators. The corpse is that of a malefactor, Adriaen Adriaensz, known as Het King, who was dissected on 31st January 1632. The group was painted for the city's Guild of Surgeons and hung in their Anatomy Theatre, where it remained until economic pressure forced them to sell. It was acquired by William I of Holland and has been in the collection of the Mauritshuis ever since. As a painting, although the finest of Rembrandt's earlier work, it shows that he had not completely mastered the unity of conception and expression that is found in the *Syndics* (plate 27). The portrait of Tulp in a stiff formality is at variance with the group of onlookers which is, within itself, somewhat ununified, the small centre group showing interest in the dissection whilst the others are posing. Nevertheless it is a remarkable painting and the use of the exposed muscles in the arm contribute a note of strong colour which gives the pallor of the corpse extra emphasis and increases the sense of life in the onlookers.

Sleeping Woman
1655–6
Brush drawing in brown ink
10 × 8 in (24.5 × 20.3 cm)
British Museum, London

Rembrandt's drawings hold a special place in the history of art. The range and quality of these alone would fully establish his genius, quite apart from any of his paintings. For Rembrandt, drawing was an essential part of life. While he worked he surrounded himself with many of his drawings for reference and inspiration. The nature of the drawings ranges from delicate lightly drawn studies, of which *Sleeping Woman* is an example, to firmly finished and detailed studies, closely cross-hatched and used as preparations for paintings or etchings.

Sleeping Woman is superb. The deep understanding of light, direction of form, structure and texture enable Rembrandt to express with immediacy and freedom the essence of his subject.

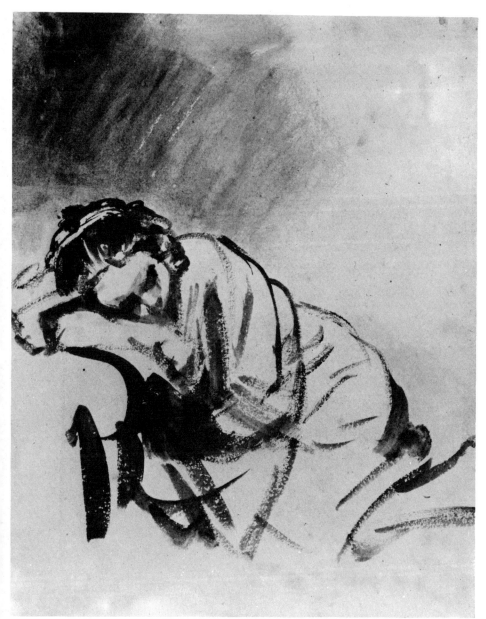

Sleeping Woman

Plate 25
The Anatomy Lecture of Dr John Deyman
Oil on canvas
40 × 52 in (100 × 132 cm)
Rijksmuseum, Amsterdam

This is the fragment of a larger painting, which was partly destroyed by fire. A drawing for the larger work exists in the Print Room of the Rijksmuseum (cf. W. Valentiner, *Handzeichnungen* 11, p. 741). Like plate 24 it was formerly in the Anatomy Theatre of the Guild of Surgeons in Amsterdam. The date ascribed to this painting is 1656.

was built. Charles Le Brun (1619–90) was effectively in charge of the work and was a painter of large Baroque compositions. Although completed after Rembrandt's death, the ceiling painting in the Hall of Mirrors is by Le Brun.

Other important painters were, firstly, the two expatriates who lived in Rome, Nicholas Poussin (1594–1665) and Claude Lorraine (1600–82), and Georges de La Tour (1593–1652), a follower of Caravaggio.

Also included are:
Jacques Callot (*c.* 1592–1635)
Le Nain brothers (spanning the years 1588–1677)
Simon Vouet (1590–1649)
Eustache Le Sueur (1616–55)

ENGLAND
This was the period covered by the early Stuarts (James I and Charles I) and the Commonwealth – not a particularly significant period in English art. The most important painter was Flemish, Sir Anthony van Dyck (1599–1641). The chief Royalist painter was William Dobson (1611–46) and the chief Protectorate painter was Robert Walker (*c.* 1610–58).

Working later in the period were:
Sir Peter Lely (1618–80)
Sir Godfrey Kneller (1648–1723)

FLANDERS
Throughout this period, Flanders was under the effectual control of Spain. The most important painter was Sir Peter Paul Rubens (1577–1640).

Others of interest were:
'Velvet' Breughel (1568–1625)
David Teniers (1610–90)
Adriaen Brouwer (1605–38)

HOLLAND
Holland was a republic with a Staatholder as head of State.

Rembrandt's most important contemporaries were Frans Hals (1580–1666) and Jan Vermeer (1632–75) but, as has been stated elsewhere, there was a large school of painting in Holland, flourishing during his lifetime, which examined most aspects of Dutch life. The most important of these are listed below:
Aelbert Cuyp (1620–91)
Gerard Dou (1613–75)
Carel Fabritius (1622–54)
Jan van Goyen (1596–1659)
Jan de Heem (1606–84)
Meindert Hobbema (1638–1709)
Gerard van Honthorst (1590–1656)
Gabriel Metsu (1629–67)

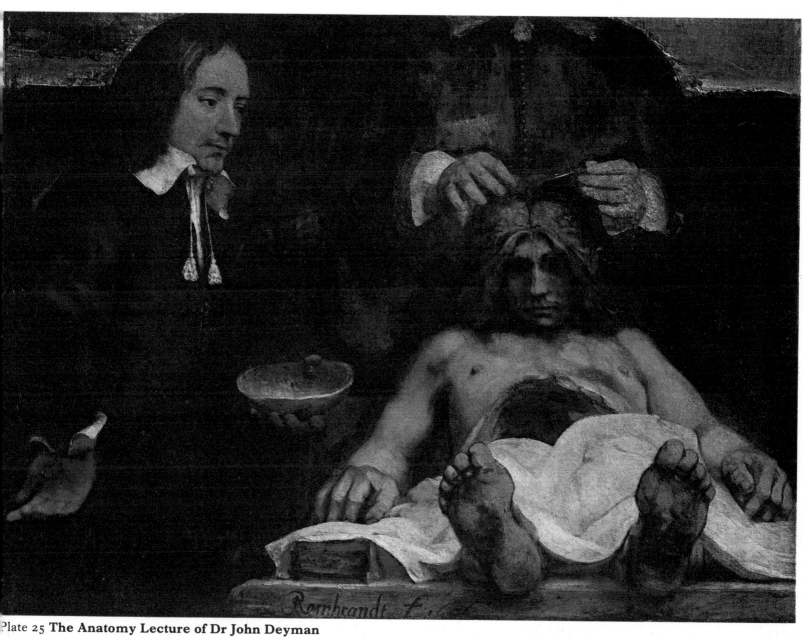

Plate 25 **The Anatomy Lecture of Dr John Deyman**

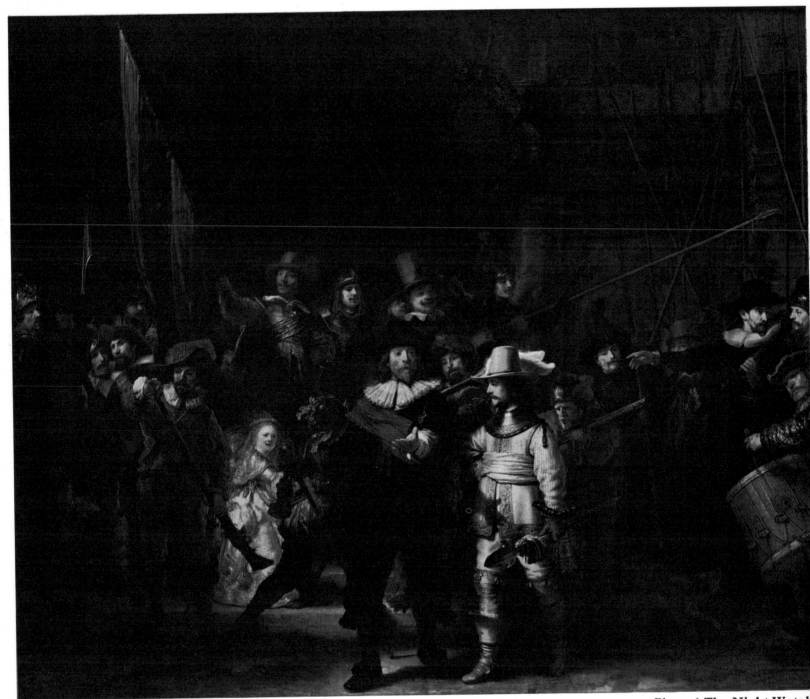

Plate 26 **The Night Watch**

Adriaen van Ostade (1610–85)
Paul Potter (1629–54)
Jacob van Ruisdael (1625–82)
Pieter Sanraedam (1597–1665)
Hercules Seghers (c. 1590–c. 1638)
Jan Steen (1626–79)
Gerard Terborch (1617–81)
Hendrikje Ter Bruggen (1588–1629)

At the end of the sixteenth century the Netherlands consisted of seventeen provinces, varied in speech–Dutch, Flemish, Walloon (linked to the Picard dialect of French)–and institutions. Antwerp then held the premier position in commerce and finance.

During the sixteenth century the Netherlands had been in revolt against the Spanish (Philip II, 1555–98). In 1567 Philip sent the Duke of Alba as Captain General with wide powers for the suppression of the revolt. He acted with extreme ruthlessness, and his name became for the Dutch synonymous with terror.

Causes of the revolt may be summarised as anti-Spanish feeling exacerbated by fiscal extortions; menace to local liberties from Hapsburg attempts at centralisation of government; religious persecution. This last had arisen from the adoption by the people of the Reformation and particularly of Calvinism or its gentler form advocated by Jacob Arminius (Arminianism). The strong Catholicism of the Spanish found these heresies intolerable and their implacable antagonism was a source of inspiration to a latent Republicanism in the Dutch.

Towards the end of the sixteenth century, the Governor General of the Netherlands, the Prince of Parma, a fine general, diplomat and statesman, exploiting the differences between the northern and southern provinces, effected the acceptance of Spanish rule by the whole area of what is now Belgium, where Catholicism predominated. At the same time, the north, by the Union of Utrecht, formed Seven Provinces, which, without absolutely repudiating Spanish rule, nevertheless demanded freedom of worship, rule by Assembly and Council, and they determined to resist all force.

The focus of Dutch revolt was in the House of Orange, and the Prince of Orange, William the Silent, was Staatholder. After his death by assassination the lead was taken by Prince Maurice of Nassau, a capable soldier who had a number of military successes, by which the Provinces continued operations against the Spanish which lasted until 1609, when the Twelve Years Truce created a territorial *status quo*.

At this time there was a remarkable development in Dutch trade so that the United Provinces became prosperous. She had become the carrier of Europe, particularly of corn and timber; the cloth trade had moved from Flanders to Holland; colonies were founded abroad; her ships were found in all the seas of the world and her sea

Plate 26
The Night Watch
Oil on canvas
146 × 175 in (387 × 502 cm)
Rijksmuseum, Amsterdam

Signed: Rembrandt f. 1642. This painting is probably responsible for the financial difficulties Rembrandt later encountered. Although the painting has come to be known as *The Night Watch* it is in fact a day scene and in sunlight. Originally it was a good deal larger, as may be judged from the important copy by Rembrandt's contemporary, Gerrit Lundens, in the National Gallery, London. It was cut down for Frans Banning Cocq, the central figure in the painting – at least twenty inches must have been removed, for instance, from the left edge. The subject represented is the group of musketeers led by Frans Banning Cocq which formed part of the Civic Guard of Amsterdam. As amateur soldiers, they were not content with the anonymity of military service and their association bears more of the character of a club. Thus, although the members of the group wanted a painting of themselves in the full military spirit, they expected to find themselves treated with more individual respect than Rembrandt accorded them. The painting of these Civic Guard groups was popular and a number of painters had produced more acceptable works of this kind, notably Cornelis van Haarlem and Frans Hals. Rembrandt's concern was clearly more with the effect of light and the offence provoked by his finished picture led to the falling off of commissions. He was paid 1600 guilders (approximately £1,200) for the painting.

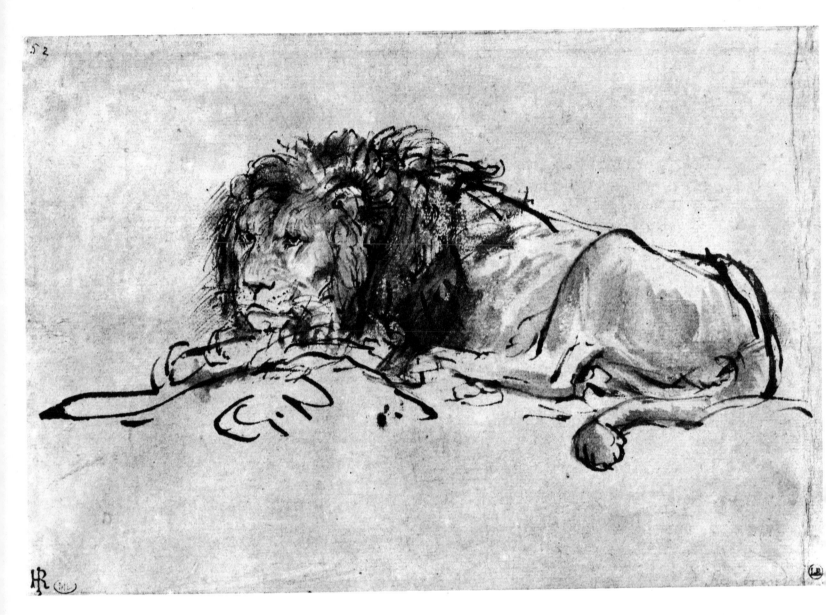

Lion
1640
Pen and wash
Louvre, Paris

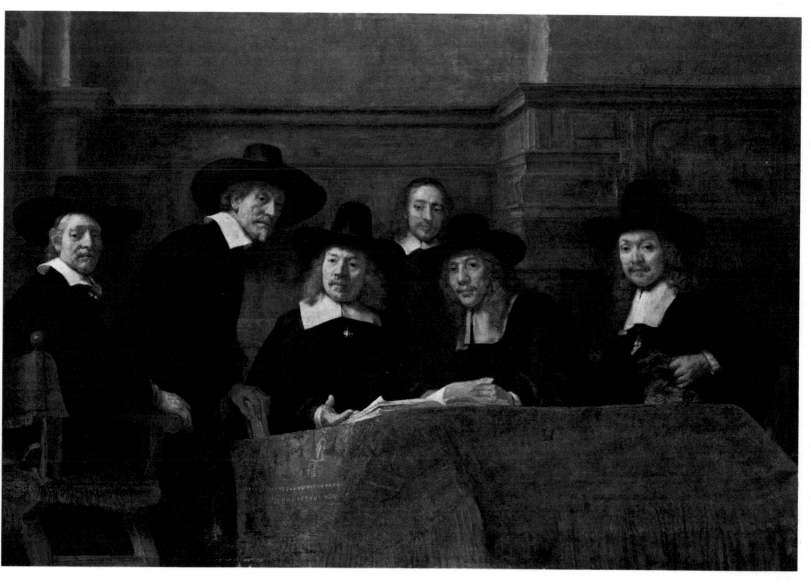

Plate 27
The Syndics of the Clothworkers Guild
Oil on canvas
74 × 109½ in (185 × 274 cm)
Rijksmuseum, Amsterdam

Signed on the tablecloth: Rembrandt f. 1662.
(The signature 'Rembrandt f. 1661', upper right,
is not original.) The greatness of Amsterdam was
based on the commercial solidity of the trading
houses and Guilds and one of the most important
was the Cloth Guild. The Syndics were elected
annually and this is the group for 1662 (whether
incoming or outgoing is not established). This
painting, discussed in the introduction, is one of
the greatest of Rembrandt's works.

Plate 28
Susannah at the Bath
Oil on panel
18 × 15½ in (47 × 39 cm)
Mauritshuis, The Hague

Signed: Rembrandt r. 1637. This is a study for the picture dated 1647 in Berlin. Ideas for the composition of the picture were derived from his master, Pieter Lastman, and there are other studies. The subject was one which might be expected to appeal to Rembrandt, as it combines the nude female figure and studies of old men. Compare this earlier painting with the *Bathsheba* (plate 29).

power grew until it triumphed over the Spanish in two important sea battles in 1631 and 1639. The Truce had lasted until 1621 when Spanish and Dutch opposition became merged in the awful brutalities of the Thirty Years War. Hostilities terminated in 1648 with the Treaty of Münster.

An important factor in understanding the position of the Dutch throughout the war is that they continued to trade with the whole of Europe, including the country they were fighting. Dutch merchants showed such concentrated industry that wealth flowed into the United Provinces, enabling it to finance its war and to achieve a sense of identity in the pride of its success. The deep Protestant faith of its people prevented complacency but it did breed confidence and energy. In freedom and tolerance a culture grew in a way that was not then possible in a Catholic country; books were printed and intellectual life was free, philosophical enquiry and religious speculation flourished in the universities (newly founded in Leyden and Amsterdam). It was in this climate of confidence and progress that Rembrandt and his contemporaries lived. It was from the rich merchants and business houses that they received their commissions as well as from the Civic Guard associations. The officers were usually drawn from the sons of the rich, and frequently these groups took on something of the spirit of a military club and as such liked to be painted as a group.

Only four years after achieving peace with Spain the Provinces were involved in a war with England. The principal causes of this war were Dutch encroachment on English-American trade and an animosity which had grown since the massacre of Amboina in 1623, when twelve Englishmen were executed by the Dutch on a charge of conspiracy; the request in the previous year for the expulsion of Royalists; above all the English Navigation Act (August 1651), which was directed against the Dutch carrying goods by requiring that the imports into England must come in English ships or in ships of the country of origin of the goods. The Dutch were required to recognise English maritime supremacy, and this led naturally to contests at sea of which there were twelve with varying success on either side. A combination of misfortunes, not the least of which was the death of their great Admiral van Tromp, brought the Dutch to sue for peace, and they found Cromwell, who had just become Lord Protector, conciliatory (particularly as the United Provinces were Protestant). The resulting Treaty of Westminster (1654) formed a basis for better relations which had no time to mature before the Restoration brought a worsening, so that again in 1665 the Second Dutch War started, lasting for two years. By then France had become the great power in Europe and the fortunes of the Dutch became involved with those of the French. But in 1669 Rembrandt died, and succeeding history is outside the scope of these notes.

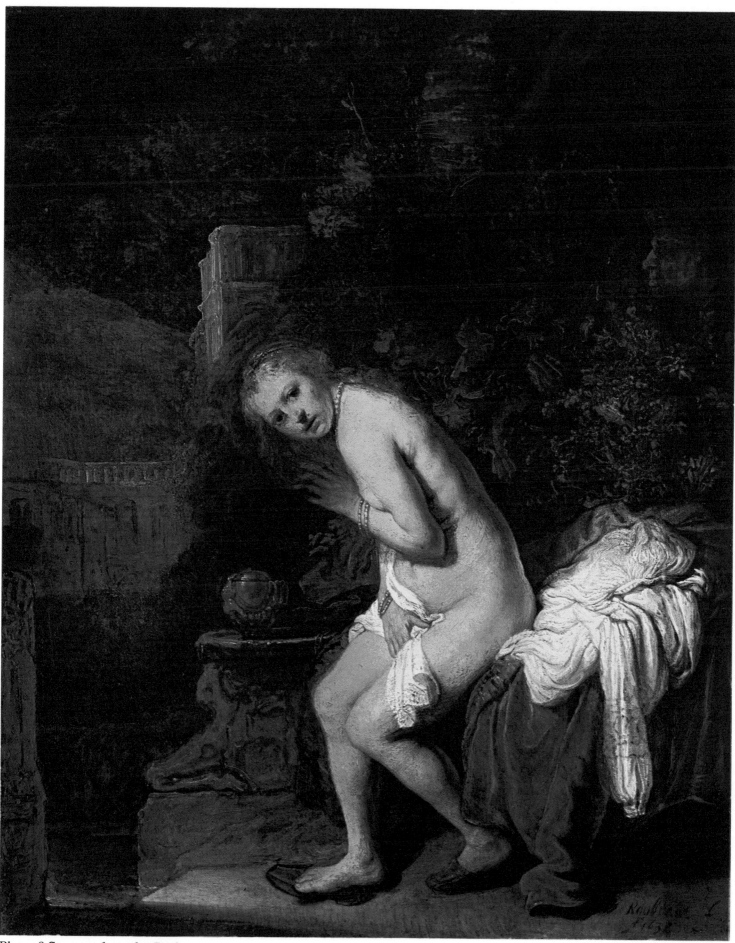

Plate 28 **Susannah at the Bath**

Kneeling Female Nude
Pen, brown ink and wash
$8\frac{7}{8} \times 5\frac{3}{4}$ in (22·5 × 14·8 cm)
Christ Church, Oxford

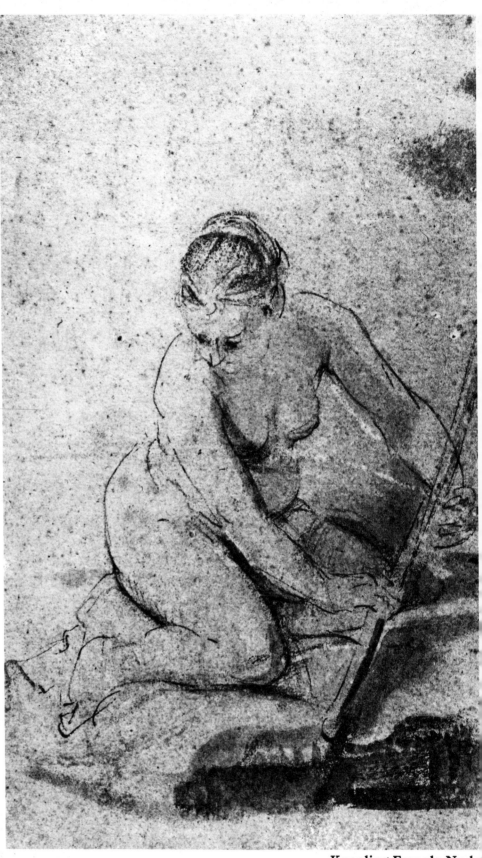

Plate 29
Bathsheba at her Toilet
Oil on canvas
56 × 56 in (142 × 142 cm)
Musée du Louvre, Paris

Signed: Rembrandt f. 1654. It is now generally accepted that the model for this painting was Hendrickje Stoffels and that it is probably Rembrandt's most magnificent nude study. The resemblance between the mature woman and the young girl of plate 10 is most marked. The warmth of the expression and the soft fleshiness of the breasts are examples of Rembrandt's mastery of the pictorial expression of human characteristics.

Kneeling Female Nude

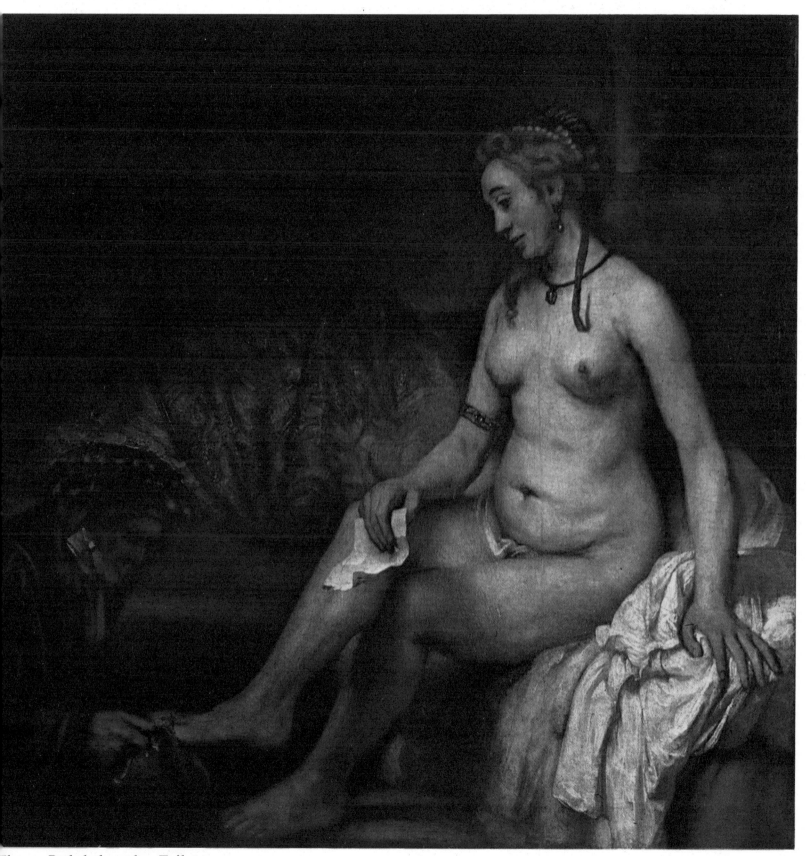

Plate 29 **Bathsheba at her Toilet**

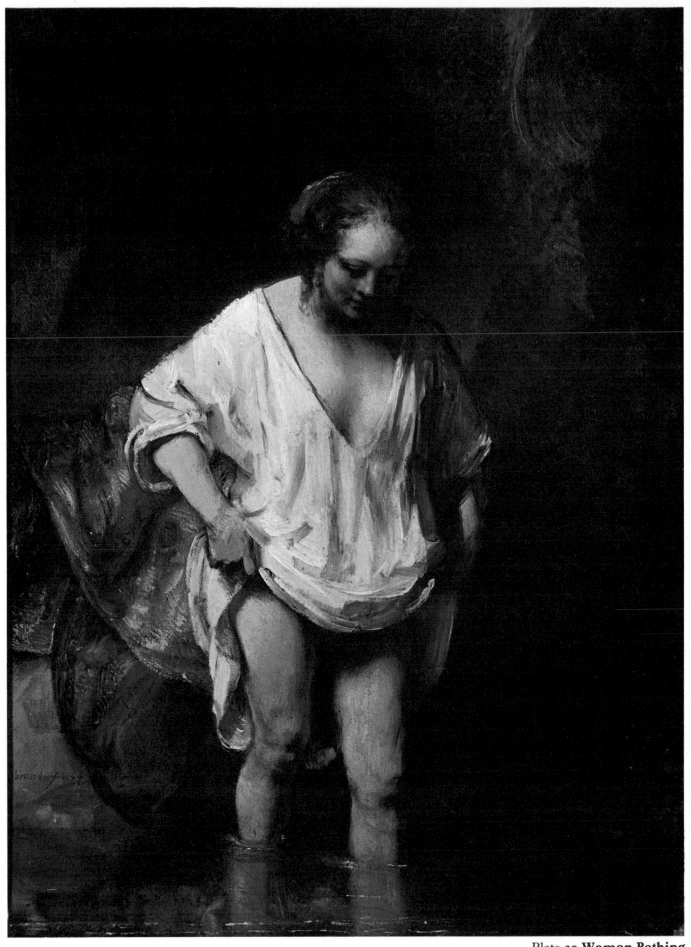

Plate 30 **Woman Bathing**

Form of contract

The following is an agreement drawn up between Titus van Rijn and Hendrickje Stoffels which was intended to give Rembrandt some escape from creditors and speculators, by furnishing him with wages, food and lodging in return for all works of art produced by him:

On 15th December 1660, Titus, assisted by his father (Rembrandt van Rijn) and Hendrickje Stoffels, who is of age and is assisted by a guardian chosen by her for the purpose, declare that they agree to carry on a certain company and business, started two years before, in paintings, pictures and paper, engravings, and woodcuts, the printings of these, curiosities, and all pertaining thereto, until six years after the death of the aforementioned Rembrandt van Rijn, under the following conditions:

Firstly, that Titus van Rijn and Hendrickje Stoffels will carry on their housekeeping and all pertaining thereto at their joint expense, and having jointly paid for all their chattels, furniture, paintings, works of art, curiosities, tools, and the like, and also the rent and taxes, that they will continue to do so. Further, both parties have each brought all they possess into the partnership, and Titus van Rijn in particular has brought his baptismal gifts, his savings, his personal earnings, and other belongings he still possesses. All that either party earns in future is to be held in common. According to this company's proceedings, each is to receive half of the profits and bear half of the losses, they shall remain true to one another in everything, and as much as possible shall procure and increase the company's profit.

But they require some help in their business, and as no one is more capable than the aforementioned Rembrandt van Rijn, the contracting parties agree that he shall live with them and receive free board and lodging and be excused of housekeeping matters and rent on condition that he will, as much as possible, promote their interests and try to make profits for the company; to this he agrees and promises.

The aforementioned Rembrandt van Rijn, however, will have no share in the business, nor has he any concern with the household effects, furniture, art, curiosities, tools and all that pertains to them, or whatsoever in days and years to come shall be in the house. So the contracting parties will have complete possession and are authorised against those who would make a case against the aforementioned Rembrandt van Rijn. Therefore, he will give all he has, or henceforth may acquire, to the contracting parties, now as well as then, and then as well as now, without having either the slightest claim, action or title or reserving anything under any pretext.

As the aforementioned Rembrandt van Rijn has recently become bankrupt and has had to hand over everything he possessed, it has

Plate 30
Woman Bathing
Oil on panel
24 × 18¼ in (61 × 46 cm)
National Gallery, London

Signed: Rembrandt f. 1654. An exquisite example of a Rembrandt study at the height of his technical power. Note the beauty of colour in the arm, the hand and the smock it holds. The model is probably Hendrickje Stoffels.

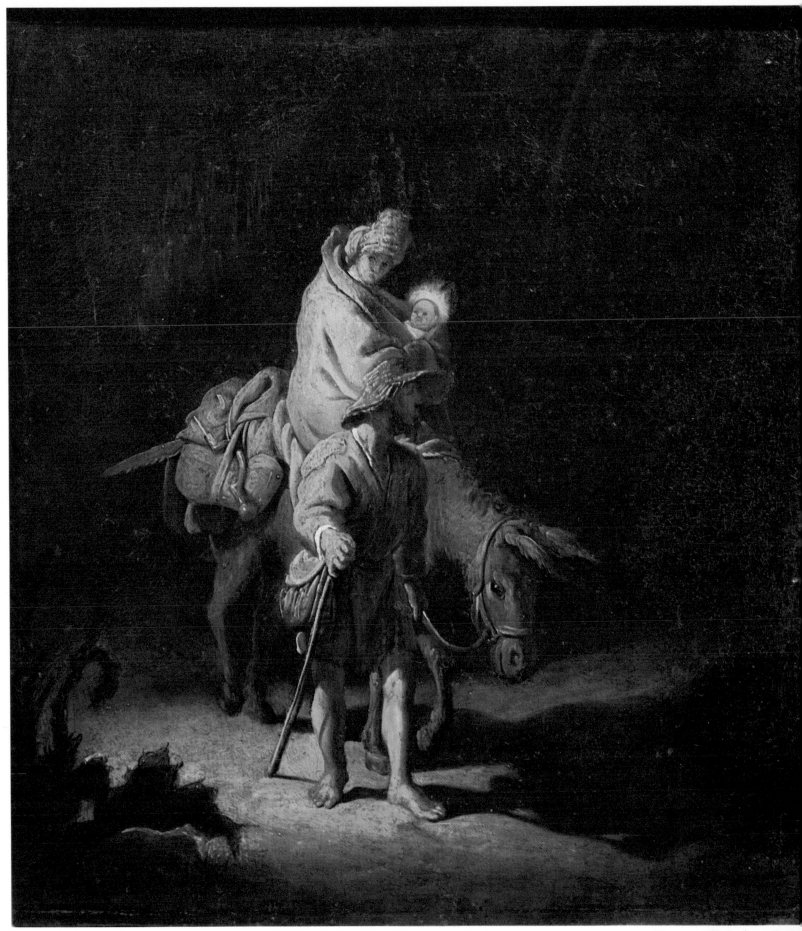

Plate 31 **Flight into Egyp**

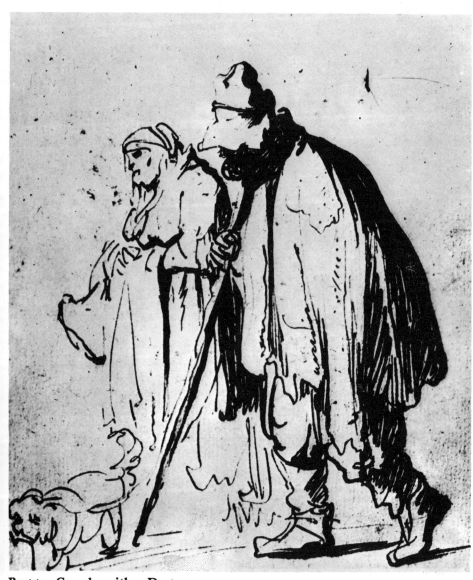

Beggar Couple with a Dog

Plate 31
Flight into Egypt
Oil on panel
$10\frac{1}{2} \times 9\frac{3}{4}$ in (26 × 24 cm)
Musée des Beaux-Arts, Tours

The date, 1625, following the monogram, has recently been revealed, making this work one of the earliest known Rembrandts. This subject was favoured by *chiaroscurists* since it gave them opportunity to achieve the dramatic effect of a single light source which isolates the Holy Family. Its treatment as a night scene was the invention of the *chiaroscurists*. This particular work by Rembrandt is discussed in an article by Dr Otto Benesch in the *Burlington Magazine*, May 1954.

Beggar Couple with a Dog
1628–9
Pen
Cassirer Collection, Amsterdam

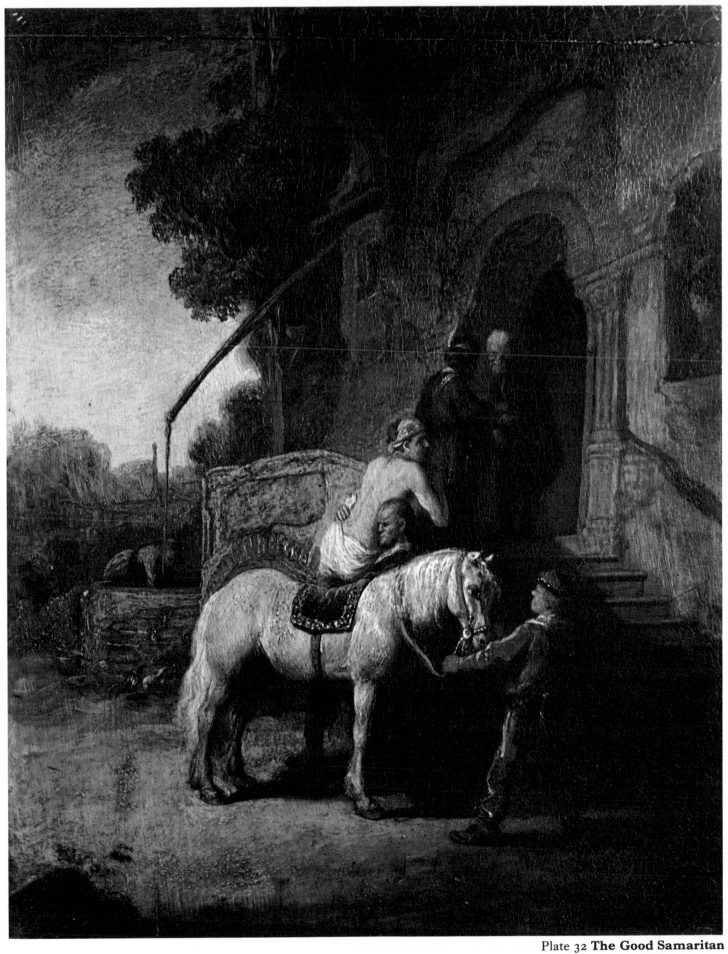

Plate 32 **The Good Samaritan**

been necessary to support him, and he acknowledges having received from the said parties the sum of 950 guilders from Titus van Rijn and 800 guilders from Hendrickje Stoffels, both sums to be used for necessities and nourishment. He promises to refund the money as soon as he has earned something again by painting. As security for both these sums the aforementioned Rembrandt van Rijn assigns to the aforementioned Titus van Rijn and Hendrickje Stoffels all the pictures he paints or sells in their house, or any that may happen to be found there, they to keep them as their own possession until they are paid for in full, without his (Rembrandt van Rijn's) exercising any action, claim or title of property to them, or reserving them under any pretext.

Moreover, the aforementioned parties further agree that no one of them, without the knowledge of the other, is to sell, embezzle, or alienate anything belonging to the company on his individual account, and if such should occur, he who will have been found to have done this must forfeit to the other the sum of 50 guilders. When this happens, this amount shall be paid by Rembrandt van Rijn out of payments which are due to each of them, by deducting from the delinquent's share which is due, so that the delinquent will receive so much less, and the others so much more, and this will be repeated if it occurs again.

(Then follows a legal epilogue and the signatures of the parties concerned, Hendrickje Stoffels being represented by a cross.)

Plate 32
The Good Samaritan
Oil on panel
$11\frac{1}{2} \times 8\frac{1}{2}$ in (27.5 × 21 cm)
Wallace Collection, London

This has been etched in reverse by Rembrandt, 1632–3. There is a later and more elaborate version of the same subject in the Louvre, but the painting illustrated shows a deeper feeling for the pathos of the subject. The pyramidal composition builds up to the anonymous dark figure paying the landlord for his attention to the poor traveller.

Landscape with Mill
Pen and bistre
Musée Condé, Chantilly

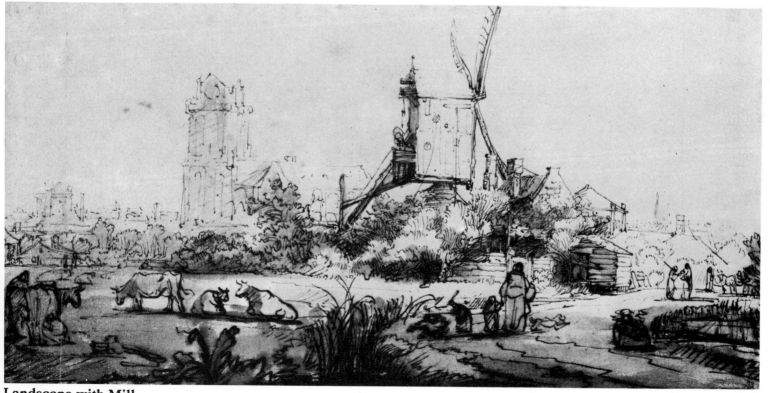

Landscape with Mill

Comments on Rembrandt

Plate 33
Simeon in the Temple
Oil on canvas
24 × 19 in (60 × 48 cm)
Mauritshuis, The Hague

Signed with monogram and dated 1631. (See Luke, chapter II, verses 25–8.) This may be examined as a remarkable tribute to Rembrandt's enormous early technical skill—he was only twenty-five. In the transparent mist in the background one can count no less than forty-two separate figures, and one should note how the lines of light on the column act as a pivot to the composition as well as emphasising the central group. This version of the subject—one of several —has been in the Royal Collection since 1763.

Contemporary and near-contemporary comments on Rembrandt

Rembrandt himself seldom expressed any definite opinions about art. Such as do survive are mostly implicit in his correspondence, especially to Constantin van Huygens, who was a politician, a man of letters and one of the first admirers of Rembrandt's art.

It was largely through van Huygens that Rembrandt obtained his commission to paint the Passion series for Frederick Henry, Prince of Orange. Here is a section of a letter to Huygens about this, dated 12th January 1639:

Because of the great joy and devotion which filled me in doing well the two works which His Excellency ordered me to make, the one where the dead body of Christ is put into the grave and the other where Christ rises from the dead to the great consternation of the guards, these same two pieces are now finished through studious application … In both I have concentrated on expressing the greatest inward emotion and feeling, and this is the main reason why the paintings have remained so long on my hands.

Other comments on Rembrandt's life and work have been numerous, of which the following are a few:

A master capable of nothing but vulgar and prosaic subjects... who merely achieved an affect of rottenness.

Gérard de Lairesse, 1669
(Lairesse was a painter [see plate 17].)

His parents put him to school so that he might learn Latin and in due course go to the University of Leyden, so that when he came of age, he might serve the town and elevate the community with his learning. But he had no wish or inclination to do so, since his inclination tended solely to the art of the painter, so his parents were forced to take him away from school and, following his desires, let him be apprenticed to a painter, to learn the rudiments of his craft. So they took him to the gifted Jacob Isaaksz van Swannenburg, who taught and instructed him, and with whom he remained for three years, during which period he made such progress that all those who loved

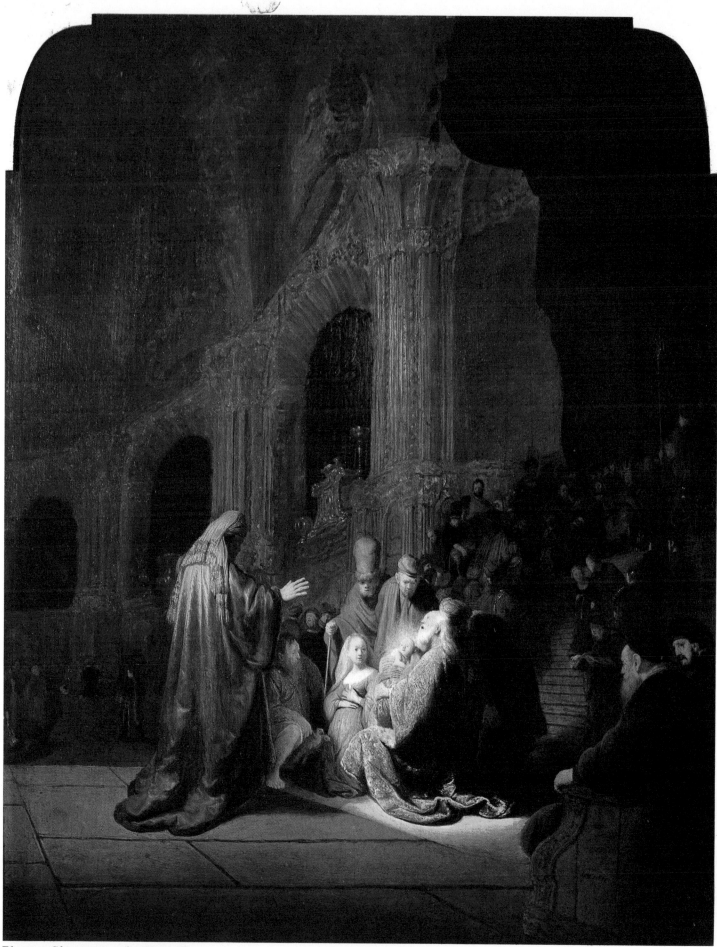

Plate 33 **Simeon in the Temple**

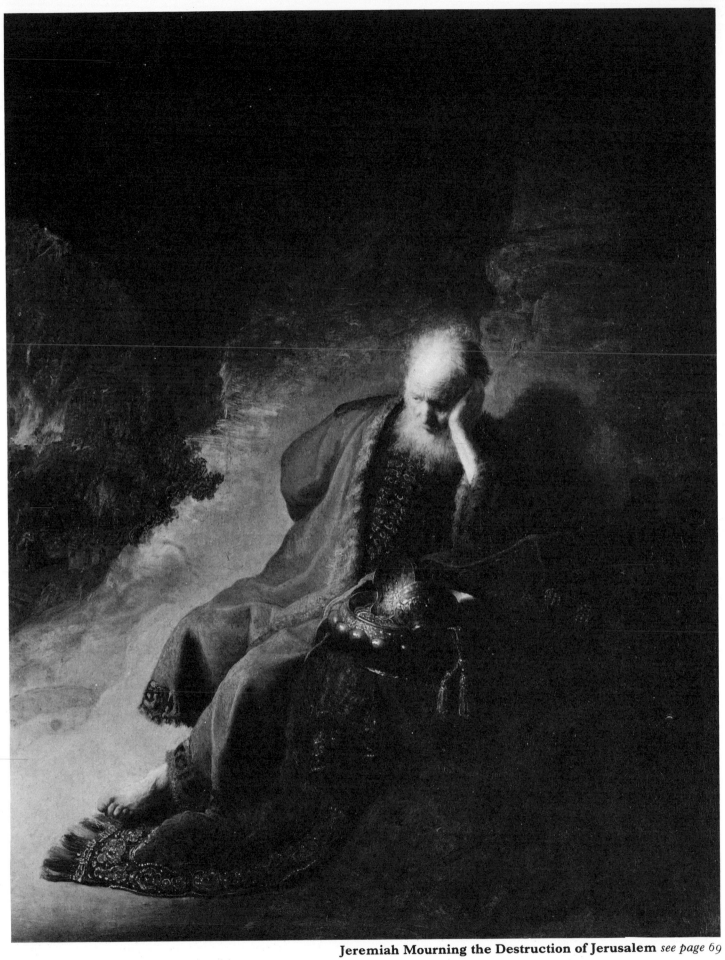

Jeremiah Mourning the Destruction of Jerusalem *see page 69*

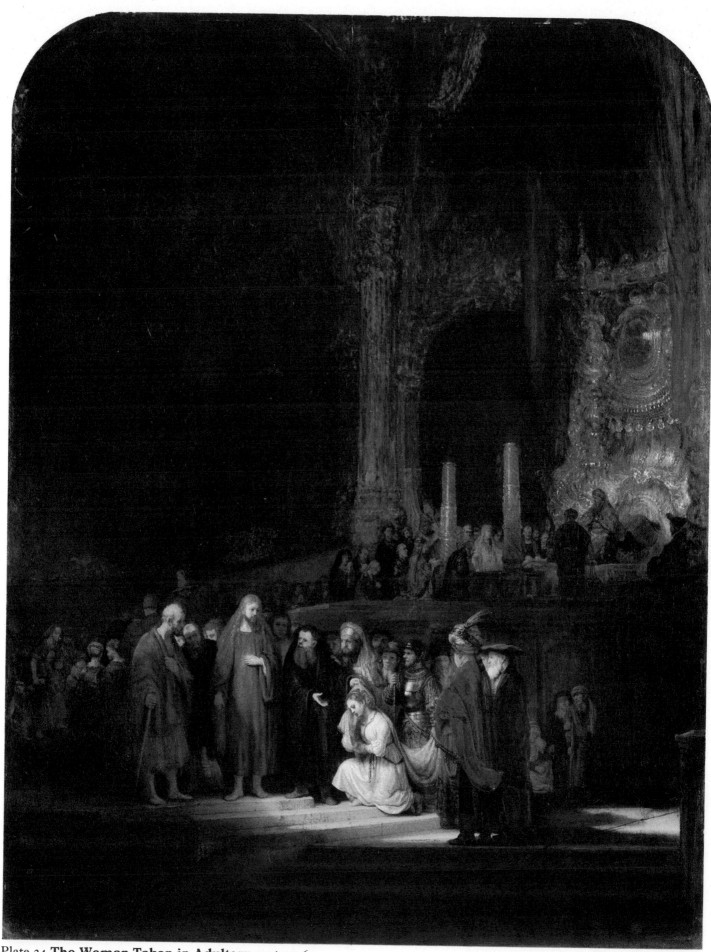

Plate 34 **The Woman Taken in Adultery** *see page 69*

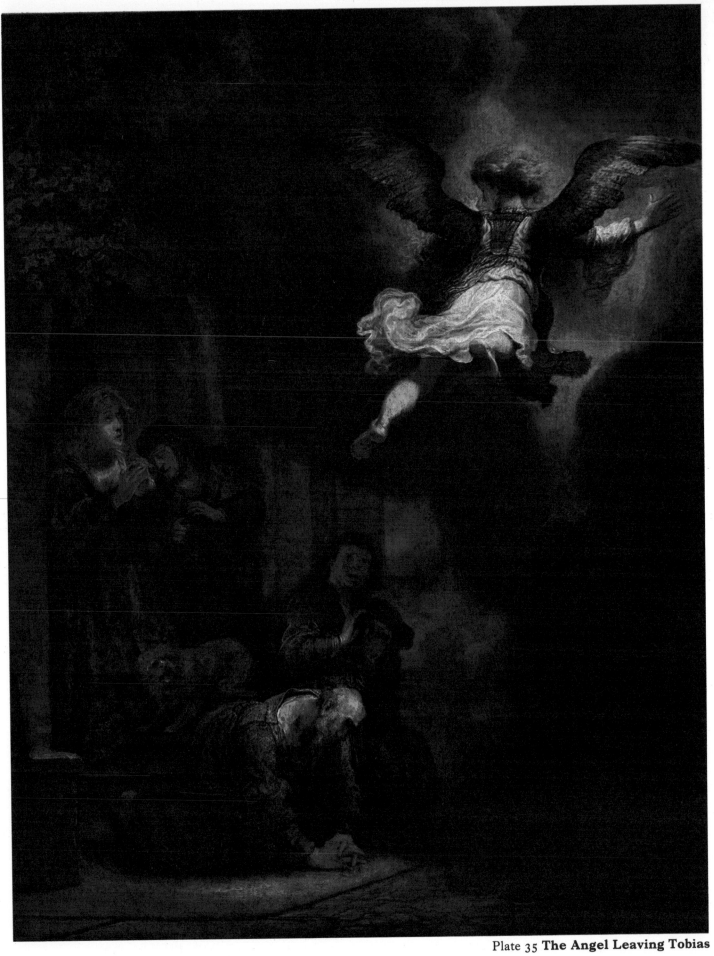

Plate 35 **The Angel Leaving Tobias**

art were most astonished, and foresaw that in the future he might become a painter of eminence. His father therefore decided to board him out with the eminent artist P. Lastman, who lived in Amsterdam, so that he might be still better taught and instructed. He stayed there for about six months, and then decided that he himself could study and practise the art of painting, in which he was so gifted that he became one of the most gifted artists of the century. Because his art highly pleased the citizens of Amsterdam, and because he received so many commissions there, he found it best to move to that city, and so left here [i.e. Leyden] about 1630, and made his home in Amsterdam, where he was still living in 1641.

J. Orlers, *Beschrijvinge der Stadt Leyden,* 1641

It is a remarkable thing that the admirable Rembrandt, springing as he did from a flat marshy country, and having the background of a miller, should yet have been so driven by nature towards the noblest art that he reached a surprising height of achievement both by his natural bent and by his application. He began at Amsterdam under the celebrated Lastman, and thanks to his natural gifts, unsparing industry and constant practice, lacked nothing but that he had not visited Italy and other places where the Antique and Theory of art may be studied, a defect all the more serious since he could but poorly read Dutch, and hence profit little from books.[1] Hence he always remained faithful to the convention which he had adopted – in direct opposition to all our art theories and teachings – anatomy, proportions, Raphael's drawing and the laws of composition – all of which are so necessary for our profession. Instead he alleged that one should be guided merely by nature and by no other rules, and accordingly as circumstances demanded he approved in a picture light and shade and the outline of objects, even if they were in flat contradiction with the simple fact of the horizon, as long as in his opinion they were necessary and apposite... He knew not only how to depict the simplicity of nature accurately, but also to adorn it with natural vigour in painting and powerful emphasis.

Joachim von Sandraert, *Deutsche Academie,*
Nuremberg, 1675

What a loss it was for art,
That such a master hand
Did not use its native strength to better purpose.
Who surpassed him in the matter of painting?
But, oh, the greater the talent the more numerous the aberrations,
When it attaches itself to no principles, no rules,
But imagines it knows everything of itself.

Andries Pels, *Gebruik en misbruik des tooneels,*
Amsterdam, 1681

[1]*Editor's Note*: This, of course, like so many of the myths which have come to attach themselves to Rembrandt, as to other famous artists, is untrue.

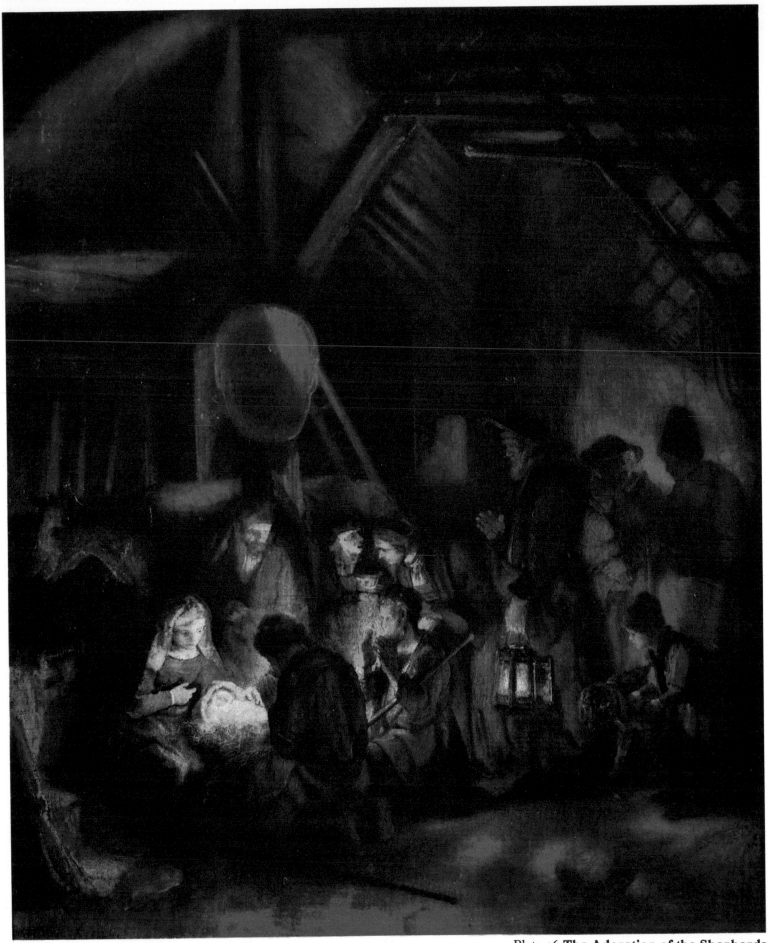

Plate 36 **The Adoration of the Shepherds**

This artist professed in those days [i.e. *c.* 1650] the religion of the *Menisti*,[1] which, though also false, is not the same as Calvinism, inasmuch as they believe in adult baptism. They do not elect educated preachers, but employ for such posts men of humble condition, as long as they are esteemed by them honourable and just people, and for the rest, they live according to their caprice.

<div align="right">Filippo Baldinucci, Cominciamento, e progresso dell'arte dell'intagliare etc., Florence, 1686</div>

Commissions flowed on him from every side, and so did pupils, to such an extent that he rented a warehouse on the Bloemengracht, in which he gave each a room for himself, often divided from that of others merely by paper or canvas, so that everyone could study from the life without disturbing anyone else. Since young people, especially if there are a lot of them together, will often get into mischief, so it happened here. As one of them needed a female model, he took her into his room. This aroused the curiosity of the others, and in their socks, so as not to be heard, they peeped through a hole in the wall. It was a hot summer's day, and to make their work easier both artist and model stripped – the merry jokes and pranks which took place between them can easily be imagined. Just then Rembrandt himself arrived to see what his pupils were up to and finding the door of this particular studio locked, was told by the onlookers what was happening and himself had a look. One of the two inside just then said to the other, 'Now we are as Adam and Eve were in Paradise, stark naked.' Rapping on the door with his mahlstick he called out, 'But because you are naked you must be chased out of Paradise.' Forcing open the door with such precipitation that they barely had time to collect their clothes, he drove them both out into the street.

<div align="right">Arnold Houbraken, Groote Schouwburgh der Nederlandsche Konstchilders en Schilderessen, Vol. 1., Amsterdam, 1718</div>

I have seen some of his paintings in which some details are treated with the most elaborate care, while the rest were daubed over, as with a house-painter's brush, without any regard to the drawing. But nothing could prevent him from doing this, and he said in justification that a painting is completed when an artist has achieved what he set out to do in it; nay, he pushed this doctrine so far that in order to give the full effect to one single pearl he daubed over a whole painting of Cleopatra. I remember in this connection one instance of his whimsicality. He was working on a portrait group of a man, woman and child. When he had half completed it, his monkey happened to die. Having no other canvas available, he painted a picture of the monkey in the portrait group. Naturally the people who had commissioned the painting did not wish it to appear like

Plate 36
The Adoration of the Shepherds
Oil on canvas
25 × 22 in (63 × 55 cm)
National Gallery, London

Signed: Rembrandt f. 1646. During this period of comparative happiness in Rembrandt's life, he painted a number of scenes of the childhood of Jesus.

[1] The *Menisti* were the followers of Arminius and generally known as Arminians. Theirs was a gentler form of Calvinism. Arminius was in Amsterdam from 1588 to 1603 and in Leyden from 1603 to his death in 1609. His name Jacob Harmensz, it may be noted, is incorporated in Rembrandt's full name.

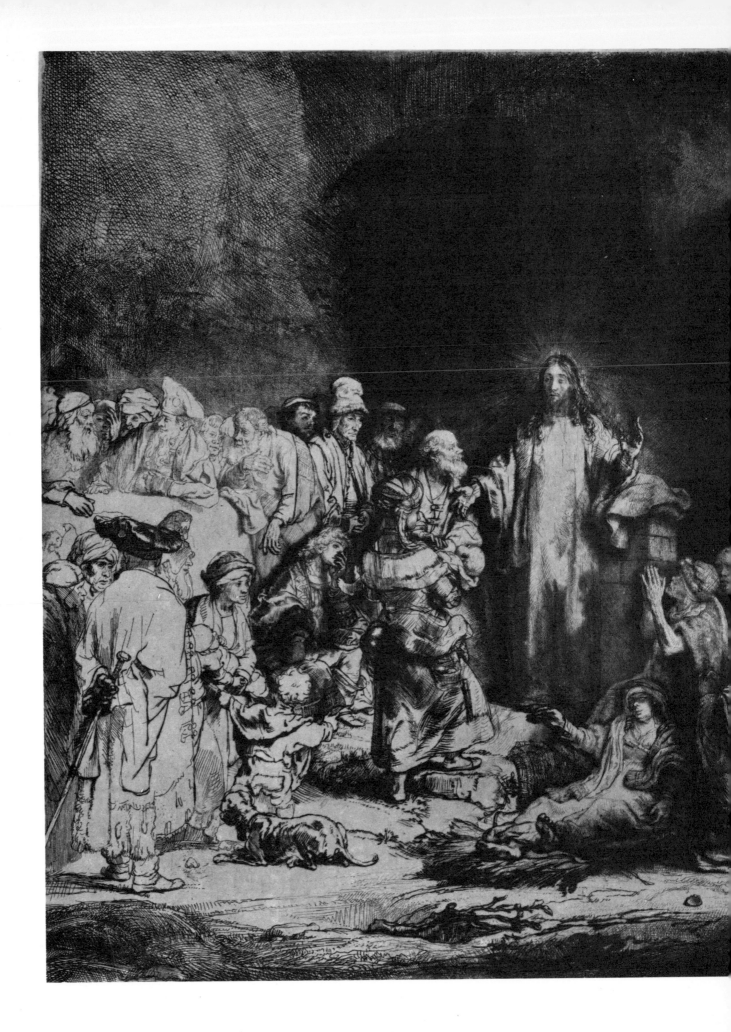

Christ Healing the Sick
called The Hundred Guilder Print
c. 1642–5
Etching
$11\frac{1}{8} \times 15\frac{1}{2}$ in (28 × 39 cm)
British Museum, London

Rembrandt stands as the one undisputed master of etching, a difficult and demanding method of reproducing from an etched plate, usually of copper. The range of line and texture is considerable, but it requires the greatest skill and understanding to use it with the freedom and assurance of a Rembrandt. The so-called *Hundred Guilder Print* is a fine example of the technique at his command. The left side of the print shows the initial drawn state before the fine cross-hatch or tone work is included. The right-hand side shows the depth of tone and sensation of light that the fully worked plate may have.

This is one of the largest and finest of Rembrandt's etchings, of which only nine of the first state exist. The name by which it is commonly known has never been explained satisfactorily, although tradition has it that this was the price at which Rembrandt first sold it. This is an attractive and a plausible explanation, but an improbable one in view of the rate of exchange prevailing at the time.

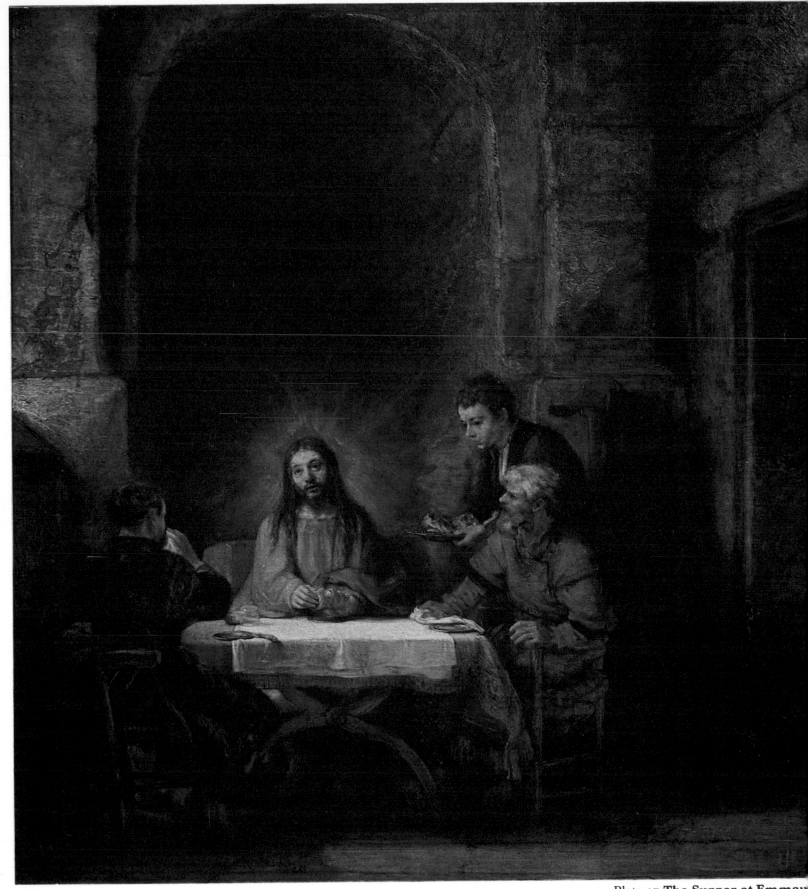

Plate 37 **The Supper at Emmau**

this, but the artist was so keen on the dead monkey that he preferred to keep the painting unfinished than give in to the wishes of his patrons. For a long time afterwards the painting in question was used as a partition in the school which he ran. There are, however, many of his paintings which have been carefully executed, and which are to be seen in many of the principal art collections, though some years ago, many of them, bought up at high prices, were exported to Italy and France.

Arnold Houbraken, *Groote Schouwburgh der Nederlandsche Konstchilders en Schilderessen,* Vol. 1., Amsterdam, 1718

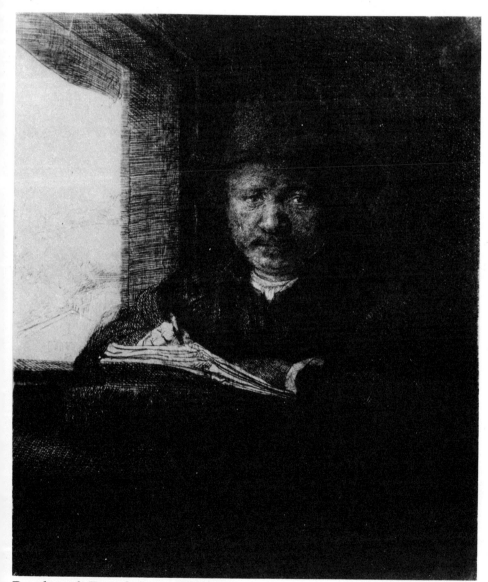

Rembrandt Drawing at a Window

Plate 37
The Supper at Emmaus
Oil on panel
27 × 25¾ in (68 × 65 cm)
Musée du Louvre, Paris

Signed: Rembrandt f. 1648. This was a subject popular with Rembrandt, as with *chiaroscurists,* and there is another version in the Louvre. The single source of light is here woven into the drama of the revelation of Christ's identity. Rembrandt, at this time, was living in the Jewish quarter of Amsterdam and he painted Christ as a Jew, perhaps using a neighbour as a model.

Rembrandt Drawing at a Window
1648
Etching, second version
6⅛ × 5 in (15 × 12 cm)
British Museum, London

This self-portrait, done when Rembrandt was forty-two, shows the firm and industrious lines of his heavy face as he searches that face in a mirror. The eyes are clear, but the lines on the face show the effects of the intense concentration and strain to which he subjected himself. This is a strongly worked plate carried to a high finish. Whilst not notably exploratory technically, it shows command of the method. This etching is contemporary with the *Hundred Guilder Print* and he may be imagined working on it in just these conditions.

Plate 38
St Peter Denying Christ
Oil on canvas
61 × 67 in (153 × 168 cm)
Rijksmuseum, Amsterdam

Signed: Rembrandt f. 1660. Formerly in the Hermitage, this is a magnificent late Rembrandt. It shows one salient characteristic of the *chiaroscurists* – a single source of light obscured, on this occasion, by the hand, giving a brilliant, surrounding reflected light without the great distortion of tones which the source, if represented, would dictate.

[1] This, the sole reference to his having been in England, is not accepted by scholars, although there is renewed discussion of the possibility.

Later comments on Rembrandt

I love *la belle nature*. Rembrandt paints caricatures.

(Letter from Lord Chesterfield to his son, 10th May 1751)

It must not be imagined that because Rembrandt was never in Rome he was ignorant of the Italian masters. He had ample material at hand which should have changed his manner or at least have corrected it. But he admired everything and profited from nothing. The Italian genius and his own had nothing in common ... His was a fiery genius, quite devoid of nobility and ignorant of the resources which Poetry provides.

J. B. Descamps (1754)

Two judgements by Sir Joshua Reynolds:

Susanna at the Bath (plate 28)
It appears very extraordinary that Rembrandt should have taken so much pains and should have made at last so ugly and ill-favoured a figure; but his attention was chiefly directed towards the colouring and effect in which, it must be acknowledged, he has attained a high degree of excellence.

The Two Anatomy Lectures (plates 24, 25)
The Professor Tulpius dissecting a corpse which lies on the table. To avoid making it an object disagreeable to look at, the figure is but just cut at the wrist. There are seven other portraits coloured like nature itself, fresh and highly finished. The dead body is perfectly well drawn (a little foreshortened) and seems to have been just washed. Nothing can be more truly the colour of dead flesh. The legs and feet which are nearest the eye are in shadow; the principal light which is on the body is by that means preserved of a compact form. All these figures are dressed in black. Above stairs [in the Surgeons' Hall] is another Rembrandt of the same kind of subject, Professor Deeman standing by a dead body which is so much foreshortened, that the hands and the feet almost touch each other. There is something sublime in the character of the head which reminds one of Michael Angelo; the whole is finely painted, the colouring much like Titian.

From *Notes on a Journey to Flanders & Holland in the Year 1781*

Two comments from Walpole's *Anecdotes of Painting*, 1786:

Rembrandt, whose peculiarity of style and felicity of glory, acquired rather by a bold trick of *chiaroscuro* than by genius, captivated the young painter (Griffier) and tempted him to pursue that manner.

Vertue was told by old Mr Laroon, who saw him in Yorkshire, that the celebrated Rembrandt was in England in 1661[1] and lived 16 or 18 months in Hull, where he drew several gentlemen and seafaring persons. Mr Dahl had one of these pictures. These are two fine

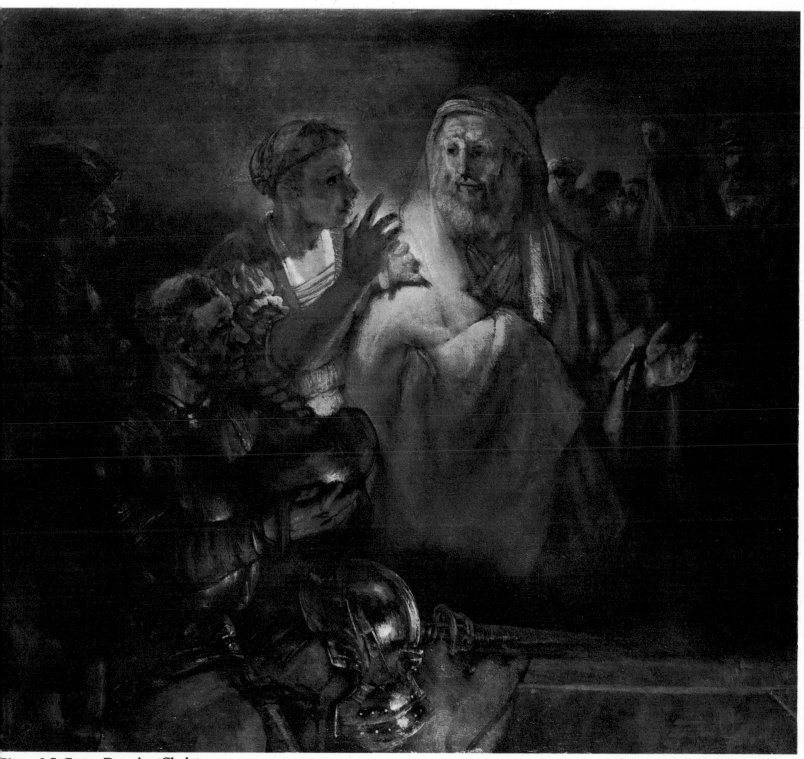

Plate 38 **St Peter Denying Christ**

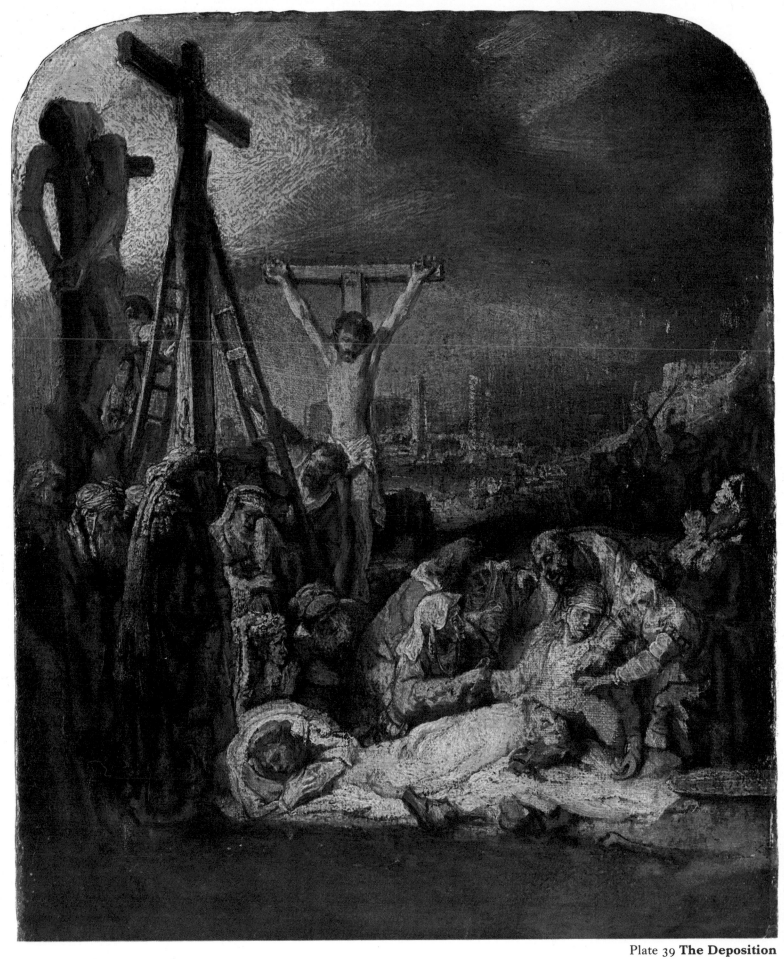

Plate 39 **The Deposition**

Plate 39
The Deposition
Oil on canvas on wood
13 × 11 in (33 × 27 cm)
National Gallery, London

This is a sketch in brown and grey. Two strips
of wood have been added above and below. The
work has passed through many distinguished col-
lections, including that of Consul Smith, George
III, Sir Joshua Reynolds and Sir George
Beaumont.

Christ and the Woman of Samaria
called **The Arched Print**
1658
Etching
6¾ × 4¾ in (16 × 12 cm)
British Museum, London

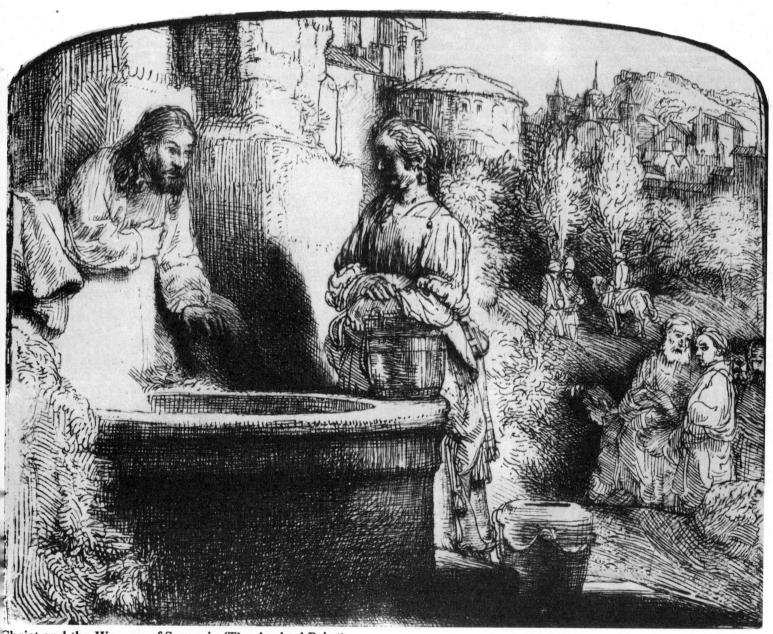

Christ and the Woman of Samaria (The Arched Print)

Plate 40 **Sophonisba Receiving the Poisoned Cup** *see page*

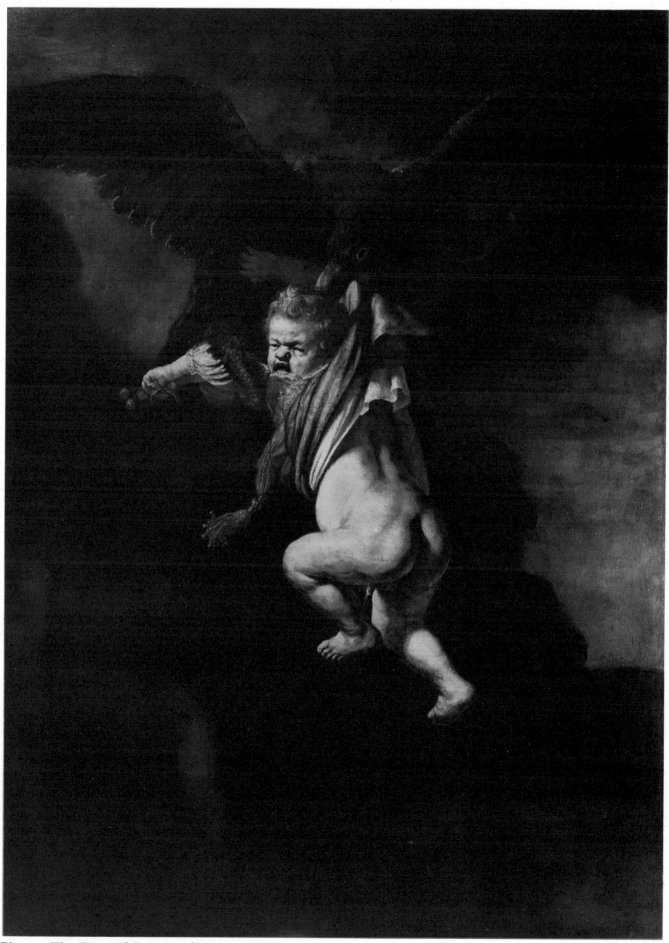

Plate 41 **The Rape of Ganymede** *see page 83*

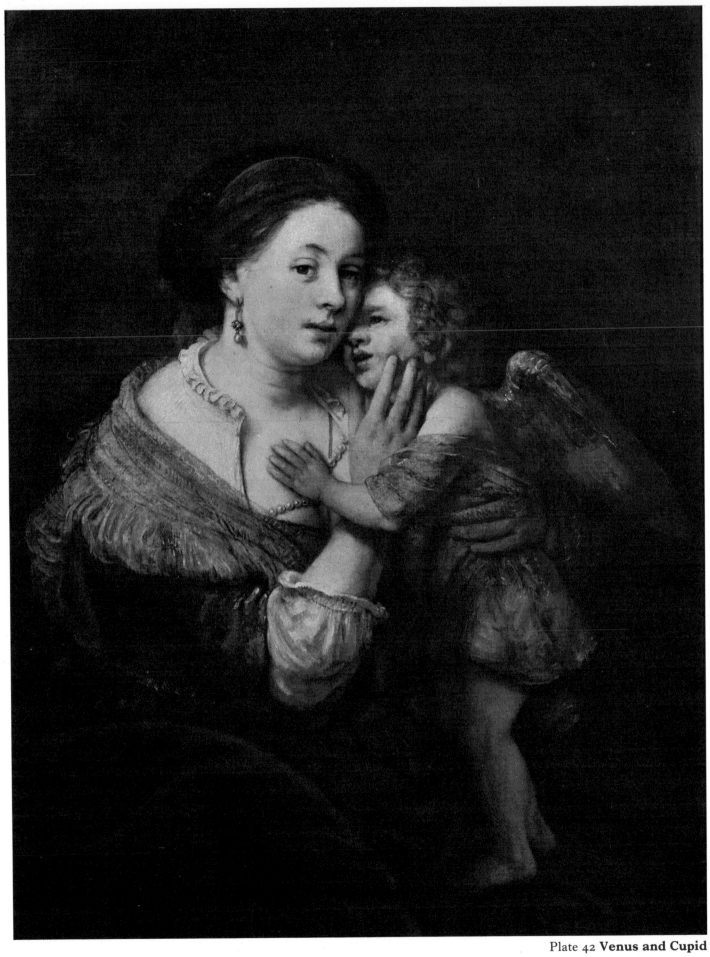

Plate 42 **Venus and Cupid**

whole-lengths at Yarmouth, done at the same time. As there is no other evidence of Rembrandt being in England, it was not necessary to make a separate article for him, especially at a time when he is so well-known and his works in such repute that his scratches, with only the difference of a black horse or a white one, sell for thirty guineas.

There is no doubt for the colouring and *chiaroscuro*, Rembrandt is one of the greatest artists that ever lived. Nothing can exceed the beauty, freshness and vigour of his tints. They have the same truth, high relish and sapidity as those of Titian. Indeed they have the closest resemblance to the hues of Titian when he mostly had Giorgione in mind. There is identically the same attention to the relief and force obtained by the strong shadows, and low deep tones; and his *chiaroscuro*, though sometimes too artificial, is yet often, particularly in contracted subjects, productive of the most fascinating effects. It may be worth observing that no part of Rembrandt's excellence is derived from the loads of colour which he has employed, or from the obtrusive, licentious, slovenly conduct of his pencil, or his *trowel* which he is said to have used.

James Barry, R.A., *Lectures on the Art of Painting*, 1798

Perhaps we shall one day find that Rembrandt is a greater painter than Raphael. I write down this blasphemy which will cause the hair of the schoolmen to stand on end without taking sides.

Delacroix (early nineteenth century)

How did I enter into Rembrandt, how drink in his excellence, how profit by his beauties! How did I recognise effects of shadow on arms, gradations of colour, softness and tones which I have seen in nature often, and which lie in my mind like substances ... Rembrandt is not vulgar, though his characters are mean; there is such refinement in his surface and colour.

Benjamin Robert Haydon, 19th June 1818 (after visiting the Rembrandts on view at the British Institution).
Autobiography and Letters of B. R. Haydon: edited from his Journals by Tom Taylor, 1853

Rembrandt's *Mill* is a picture wholly made by *chiaroscuro*; the last ray of light just gleams on the upper sail of the mill, and all other details are lost in large and simple masses of shade. *Chiaroscuro* is the great feature that characterises his art, and was carried further by him than by any other painter, not excepting Correggio. But if its effects are somewhat exaggerated by Rembrandt, he is always so impressive that we can no more find fault with his style than we can with the giant forms of Michael Angelo. Succeeding painters have sometimes, in their admiration for *The Mill*, forgotten that Rembrandt chose the twilight to second his wishes, and have fancied that to obtain equal

Plate 40
Sophonisba Receiving the Poisoned Cup
Oil on canvas
56 × 60 in (142 × 153 cm)
Museo Nacional del Prado, Madrid

Signed: Rembrandt f. 1634. (See Livy xxx 15.) Sophonisba was a Carthaginian, daughter of Hasdrubal, living in the third century B.C. She was the victim of political intrigue between Romans and Numidian princes, one of whom she was to have married but who sent her poison to prevent her falling into the hands of the Romans. This is a good example of Rembrandt's unconcern for accuracy of period in historical or religious pictures. Neither dress nor furnishings are made to relate to the pre-Christian Roman era. The model appears to be Saskia, whom he married in the same year (cf. *Saskia as Flora*, plate 9).

Plate 41
The Rape of Ganymede
Oil on canvas
$67\frac{3}{8} \times 51\frac{1}{4}$ in (171 × 130 cm)
Staatliche Kunstsammlungen, Dresden

Signed: Rembrandt f. 1635. This is one of a number of allegorical subjects painted by Rembrandt between 1630 and 1636. There are many versions of the legend of Ganymede and he is a favourite subject in classical art. Zeus, entranced by his beauty, determined that Ganymede should become his cup-bearer and so had him carried off by an eagle. To compensate King Tros for the loss of his son, Zeus made him a present of a pair of divine horses. Rembrandt gives this classical subject an intensely human quality, with the plump little boy thoroughly terrified and urinating in fright. This is a good example of Rembrandt's earlier style. The technique is less assured, the forms are harder and the handling of light and shade are coarser than in his later work.

Plate 42
Venus and Cupid
Oil on canvas
44 × 35 in (109 × 88 cm)
Musée du Louvre, Paris

This is a delicate and sympathetic portrait of Hendrickje Stoffels.

Plate 43
The Centurion Cornelius
Oil on canvas
$70\frac{1}{2} \times 85\frac{3}{4}$ in (179×218 cm)
Wallace Collection, London

There are indistinct traces of a date (?1655). The story of Cornelius is in Acts, chapter X. The central figure resembles Carel Fabritius, one of Rembrandt's pupils, and the painting has been ascribed to Bernard Fabritius, Carel's brother. The attribution to Rembrandt is now generally accepted. The painting was bought from the Royal Collection by Lord Hertford in 1848 for £2,300.

Plate 44
Man in Armour
Oil on canvas
$53\frac{1}{2} \times 40\frac{1}{2}$ in (136×102.5 cm)
Glasgow Art Gallery and Museum

Signed: Rembrandt f. 1655. This painting once belonged to Sir Joshua Reynolds (cf. his comments on Rembrandt, p. 76). It is a magnificent example of Rembrandt's technical mastery of the rendering of material, metal and flesh.

Plate 43 **The Centurion Cornelius**

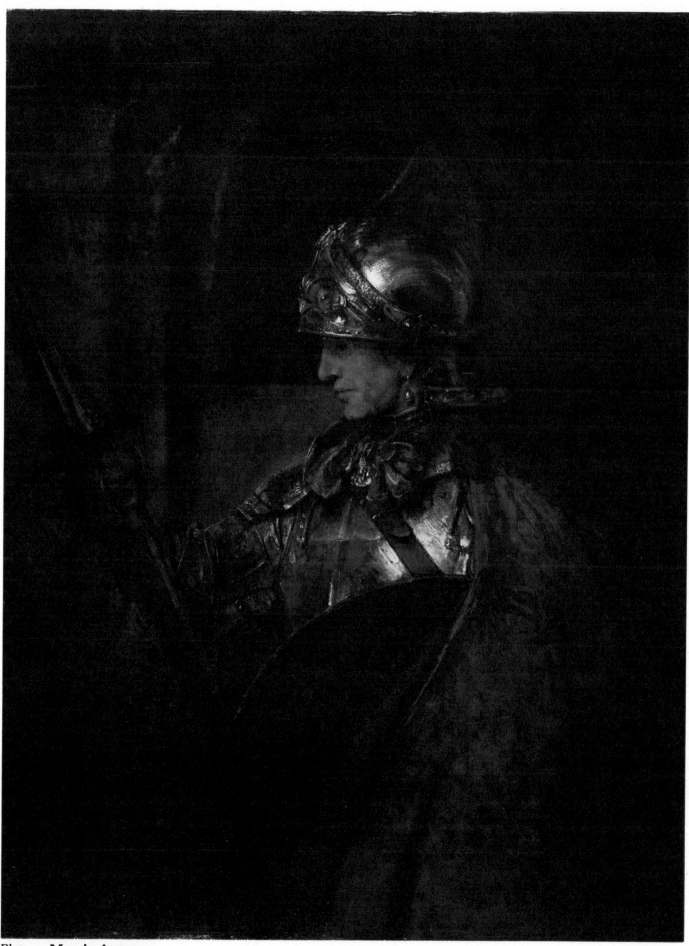

Plate 44 **Man in Armour**

View of Amsterdam
1641
Etching
$4\frac{1}{2} \times 6$ in (11×15 cm)
British Museum, London

The execution of this simple flat landscape study is remarkably fine and delicate. Rembrandt drew and etched a number of landscapes similar in character to his landscape paintings.

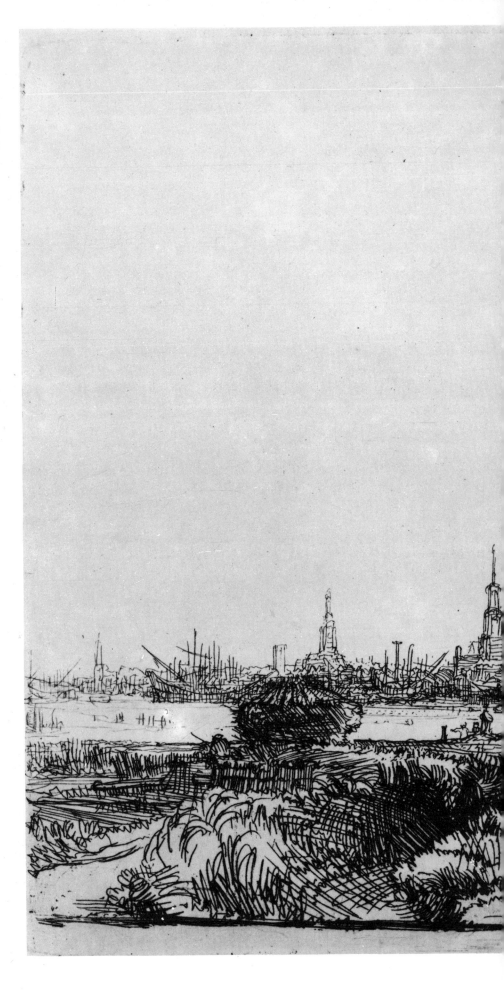

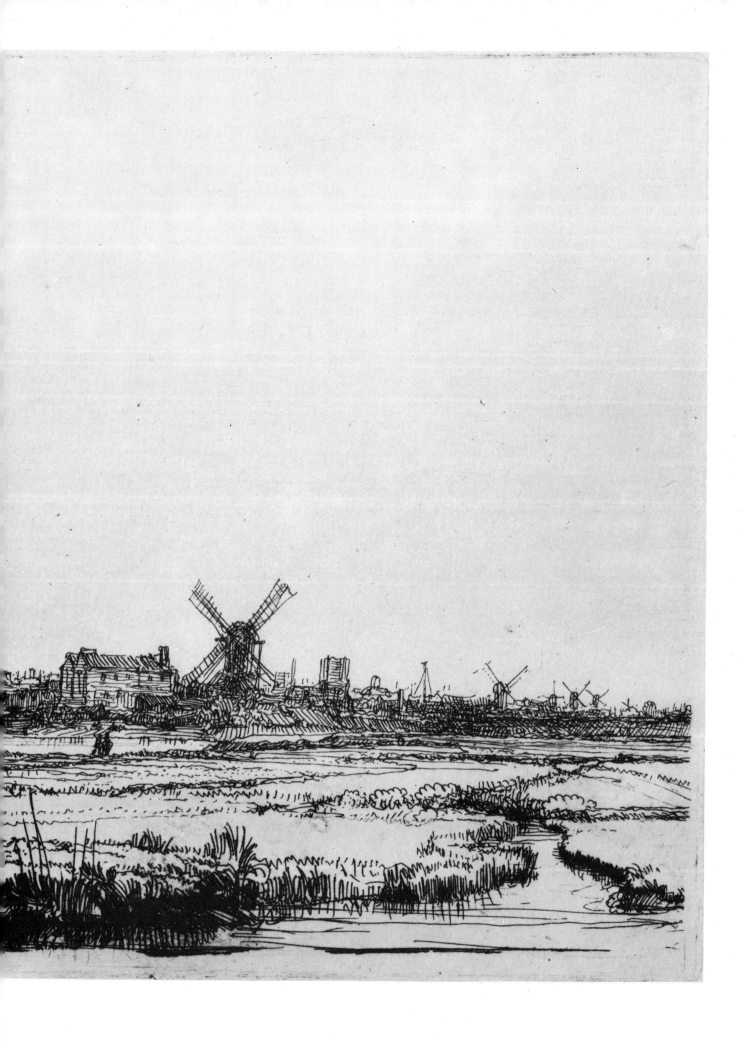

breadth, they must leave out the details of nature in broad daylight.

John Constable at the Royal Institution on 9th June 1836

He accosts with his dark lantern the world of the marvellous, of conscience and the ideal. He has no equal in the power of showing the invisible.

Fromentin (mid nineteenth century)

The light is not Rembrandtesque on the current or banks of a river; but it is on those of a drain. Colour is not Rembrandtesque usually in a clean house; but is presently obtainable of that quality in a dirty one. And without denying the pleasantness of the mode of progression which Mr Hazlitt describes as obtainable in the background of Rembrandt—'you stagger from one abyss of obscurity to another'—I cannot feel it an entirely glorious speciality to be distinguished, as Rembrandt was, from other great painters, chiefly by the liveliness of his darkness and the dullness of his light. Glorious or inglorious the speciality itself is easily definable. It is the aim of the best painters to paint the noblest things they can see by sunlight. It was the aim of Rembrandt to paint the foulest things he could see—by rushlight.

Ruskin, *Cestus of Aglaia*, 1864

This is an early Ruskin comment.

But, oh, what an orgy of self indulgence for one's eyes—and what joy—mirrored in his old, toothless mouth—are there to be found in the self-portrait of that old lion Rembrandt, with a linen cap on his head, and his palette in his hand!

Van Gogh, *Letters to Emile Bernard*

Rembrandt has a unique place in the history of European art because he united in his spirit a dramatic and psychological imagination of Shakespearian intensity and an equally great plastic imagination. In his early work the illustration of psychological conceptions sometimes spoils the complete formal unity, but in his later years he accomplished a perfect fusion of the two elements in his imaginative life.

Roger Fry, *The Arts of Painting and Sculpture*, 1932

Since the days of Sir Joshua it has been fashionable to see Rembrandt through brown spectacles, and as lately as ten years ago, his pictures in some great public collections still received new coats of brown varnishes that his mystery might be preserved. Every now and then an enlightened gallery director, or a genuine collector, shows us the man in his true colours, and we can see his greatness as a result of a fusion in his genius of absolute technical mastery with unexampled humanity and powers of penetration.

Christopher Norris, *Dutch Paintings of the 17th Century*,
An Arts Council Exhibition; illustrated catalogue, 1945

Plate 45
Scholar in an Interior
Oil on panel.
11 × 12 in (29 × 33 cm)
Musée du Louvre, Paris

Signed RHL van Rijn 1633. Rembrandt painted a number of dark, quiet interiors with the scholars in meditation or study (cf. similar work in the National Gallery, London), giving him opportunity for the expression of the remote, disinterested isolation to be found in study.

Plate 45 **Scholar in an Interior**

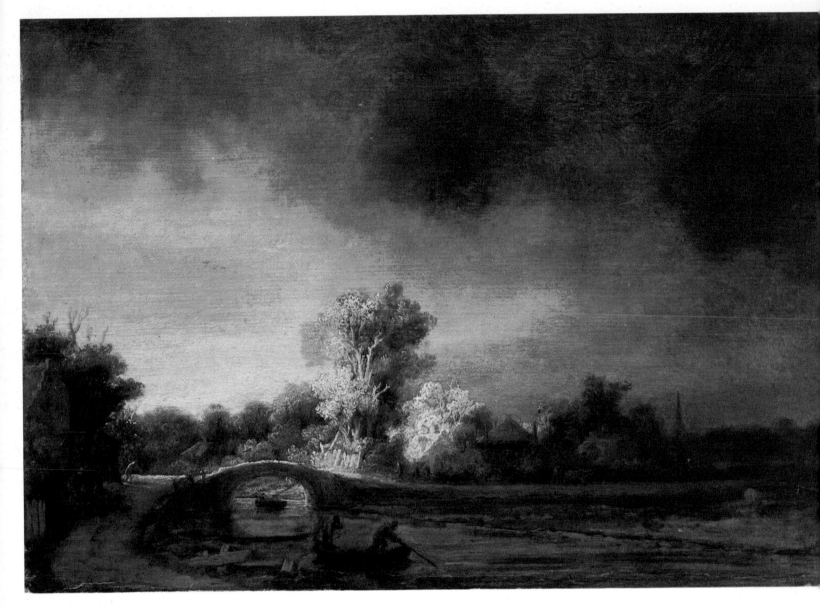

Plate 46
The Stone Bridge
Oil on canvas
$11\frac{1}{2} \times 16\frac{3}{4}$ in (28×42 cm)
Rijksmuseum, Amsterdam

Probably painted *c*. 1638. Rembrandt painted a
number of landscapes in which, as in this typical
example, there is an atmosphere of presaged
storm with strongly dramatic lighting. Ruisdael
and Philips de Koninck also produced paintings
in similar mood. The low eye level, the large
proportion of sky and intimate foreground detail,
are characteristic of seventeenth-century Dutch
landscapes, where the flatness of the countryside
and the greatly varying weather effects visibly
dominate the scene.

Plate 47
Landscape with Coach
Oil on panel
18 × 26 in (46 × 64 cm)
Wallace Collection, London

Perhaps even more dramatically intense than *The Stone Bridge* (plate 46), this landscape has a brooding grandeur and mystery which reveals Rembrandt's view of nature as that of the Protestant respect and awe in face of the work of God. Rarely do Rembrandt's landscapes show a peaceful open pastoral scene. They are suffused with a glow of almost unearthly light which hides as much as it reveals. Compared with the assertive strength of a Rubens landscape, in which the painter seems to command the scene, Rembrandt's landscapes seem full of humility and love.

The Windmill
1641
Etching
8⅛ × 5⅞ in (20 × 14 cm)
British Museum, London

This print exists in only one state. The windmill was at one time believed to have been the birthplace of Rembrandt. This, however, was not true, although it may have stood on the banks of the river Rijn, from which Rembrandt derived part of his name. Both this landscape and the *View of Amsterdam* (pages 86–7) show how intractable the flat Dutch landscape is for any attempt at dramatic treatment.

Plate 48
The Slaughter House
Oil on panel
28½ × 20½ in (72 × 52 cm)
Art Gallery and Museum, Glasgow

Signed: Rembrandt f. 16. The subject was one which appealed to Rembrandt and there are other versions in the Louvre and in private collections. These have frequently been cited as examples of the artist's ability to choose pictorial material from apparently unpromising sources.

Serious scholars have, however, long realised the falsity of the over-sentimental picture of the poverty-stricken, aged Rembrandt painted in popular art histories and in novels about the artist. The new house in the Rosengracht was spacious, and not only did Rembrandt continue to receive public commissions, but he was enabled to work with greater freedom than before, unhindered by any concessions to bourgeois taste. For the first time his technique reaches its full maturity, and he achieves new effects undreamt of in his earlier periods. By the use of thick pigment in some part, and thin glazes in others, he combines richness and subtlety in a wholly novel manner.

Moreover, if we are entitled to judge the artist's intentions from his surviving works, his choice of theme changed also, and we can clearly see the effect of his altered circumstances on his art ... One type of subject, however, seems to have fascinated him during the years immediately after the catastrophe, that is to say during the early 'sixties, when he depicted a series of calm, contemplative holy men who had experienced the sufferings of life. Setting and landscape no longer interest him; but from his own experience he draws images, ever increasing in intensity, of men who have suffered for their convictions.

Ludwig Münz, *Burlington Magazine*, March 1948

The Windmill

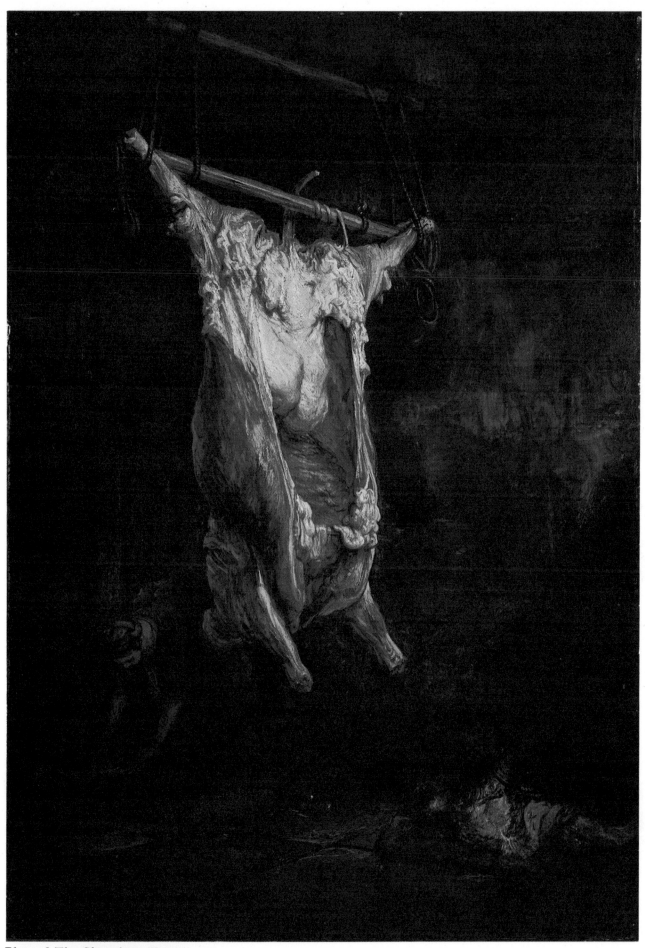

Plate 48 **The Slaughter House**

Acknowledgments

The Publishers wish to express their gratitude to all those who have allowed items in their collections to be illustrated in this book and to those who have supplied photographs. The drawing on page 56 is reproduced by courtesy of the Governing Body of Christ Church, Oxford.

Sources of photographs

(The numbers refer to the pages on which they are reproduced)
Alinari, Florence 15; Art Gallery & Museum, Glasgow 85, 93; Ashmolean Museum, Oxford 29; Christie, Manson & Woods, London 27; Courtauld Institute of Art, London 75, 92; Deutsche Fotothek, Dresden 23; Photographie Giraudon, Paris 52, 60, 63, 81, 82; Hamlyn Group Picture Library 6, 10, 13, 14, 16, 22, 26, 30, 32, 37, 39, 40, 43, 44, 47, 57, 58, 62, 68, 70, 74, 80, 84, 89, 91; Hamlyn Group–J. R. Freeman & Co. 72–73, 79, 86–87; Librairie Larousse, Paris 33, 61; Mansell Collection, London 18; Mauritshuis, The Hague 19, 29, 25, 28, 34, 46, 55, 65; National Gallery, London 8, 11, 38, 67, 78; Rapho Agence Photographique, Paris 50; Rijksmuseum, Amsterdam 45, 49, 53, 66, 77, 90; Staatliche Graphische Sammlung, Munich 17; Victoria and Albert Museum, London 2; Walker Art Gallery, Liverpool 56.

Index